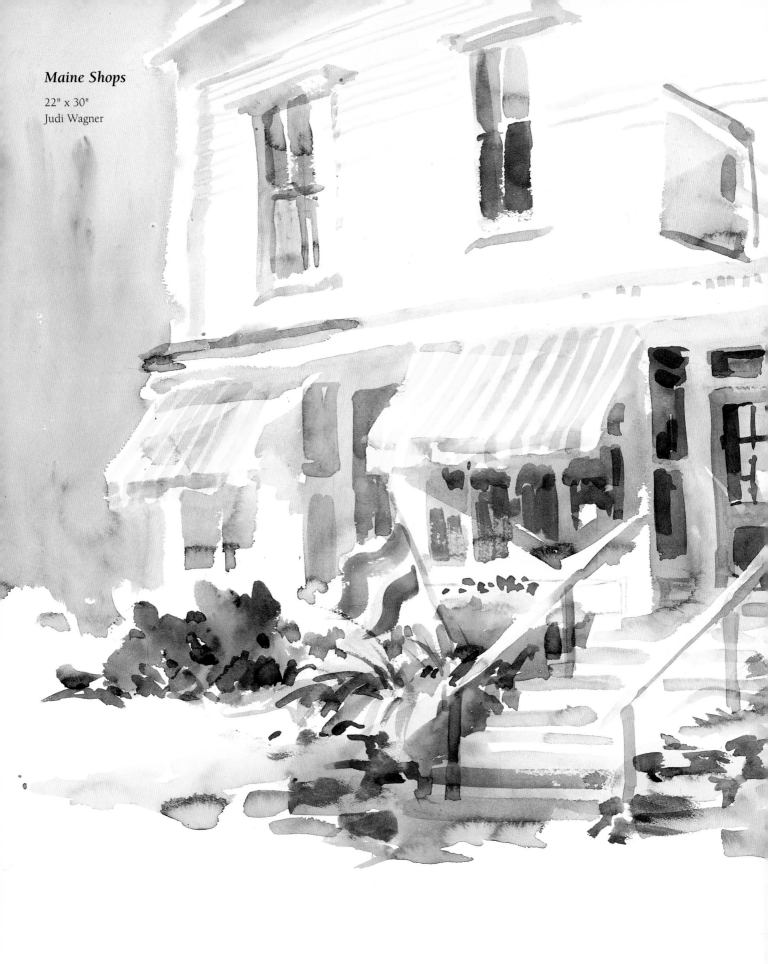

Maine Shops

22" x 30"
Judi Wagner

Painting
with the
White
of Your
Paper

JUDI WAGNER &
TONY VAN HASSELT

NORTH LIGHT BOOKS
CINCINNATI, OHIO

Painting with the White of Your Paper. Copyright ©1994 by Judi Wagner and Tony van Hasselt. Printed and bound in Hong Kong. All rights reserved. No part of this book may be reproduced in any form or by any electronic or mechanical means including information storage and retrieval systems without permission in writing from the publisher, except by a reviewer, who may quote brief passages in a review. Published by North Light Books, an imprint of F&W Publications, Inc., 1507 Dana Avenue, Cincinnati, Ohio 45207. 1-800-289-0963. First edition.

98 97 96 95 94 5 4 3 2 1

Library of Congress Cataloging-in-Publication Data

Wagner, Judi
 Painting with the white of your paper/ by Judi Wagner and
 Tony van Hasselt.–1st ed.
 p. cm.
 Includes index.
 ISBN 0-89134-580-9
 1. Watercolor painting–Techniques. I. Van Hasselt, Tony.
 II. Title.
 ND2420.W32 1994
 751.42'2–dc20 94-25382
 CIP

Edited by Rachel Wolf and Kathy Kipp
Interior designed by Paul Neff

METRIC CONVERSION CHART

TO CONVERT	TO	MULTIPLY BY
Inches	Centimeters	2.54
Centimeters	Inches	0.4
Feet	Centimeters	30.5
Centimeters	Feet	0.03
Yards	Meters	0.9
Meters	Yards	1.1
Sq. Inches	Sq. Centimeters	6.45
Sq. Centimeters	Sq. Inches	0.16
Sq. Feet	Sq. Meters	0.09
Sq. Meters	Sq. Feet	10.8
Sq. Yards	Sq. Meters	0.8
Sq. Meters	Sq. Yards	1.2
Pounds	Kilograms	0.45
Kilograms	Pounds	2.2
Ounces	Grams	28.4
Grams	Ounces	0.04

ABOUT THE AUTHORS

DEDICATION

After more than twenty years of conducting workshops throughout the country and abroad, Judi Wagner and Tony van Hasselt thoroughly enjoy working in and around their summer studios in East Boothbay, Maine. Their winter studios are on Amelia Island in Florida. The artists coauthored *The Watercolor Fix-It Book* and have been featured in *Splash 2*, as well as in *Learn Watercolor the Edgar Whitney Way* (all North Light Books). They each have produced several teaching videos and teach together on an annual painting cruise.

Judi Wagner earned her B.F.A. from Parsons School of Design and her master's degree from Parsons and Bank Street College of Education. Her background includes graphic design, theater design and printmaking. Her work has been exhibited in the annual shows of the American Watercolor Society, the Audubon Artists, and the National Arts Club and Salmagundi Club in New York City, as well as in various other shows throughout the country.

Tony van Hasselt was born in The Netherlands. He started in commercial design and art-related fields before studying under Frank Reilly in New York. As one of the first workshop pioneers, he started *Painting Holidays* and worked with its faculty of well-known painters. He was elected to the American Watercolor Society in 1972. His work has been featured in publications such as *Southwest Art* and *American Artist,* as well as William Condit's *Transparent Watercolor* and Valfred Thelin's *Watercolor, Let the Medium Do It*. He has authored two previous instruction books, as well as articles for regional publications and *The Artist's Magazine*. He continues teaching a few workshops each year.

We are honored to dedicate this book to our instructors, who were information bridges for our own art explorations. Now that we are one of those bridges ourselves, we pass on their viewpoints as well as our own experiences. Our gratitude goes to all those students who offered encouragement for this project.

A special thanks to our editors, Rachel Wolf, Kathy Kipp and their competent staff, who turned our efforts into a cohesive and visually exciting unity.

And last, this book just wouldn't have come into existence without the warm cooperation of all those contributing artists who generously shared their thoughts, experience and talents. Blessings to each of you!

Mary DeLoyht-Arendt, Rex Brandt, Jackie Brooks, Jane Burnham, Dan Burt, Ruth Cobb, Tony Couch, Carl J. Dalio, Pat Deadman, George W. Delaney, Marilyn Edmonds, Nita Engle, Serge Hollerbach, Philip Jamison, Zygmund S. Jankowski, George Kountoupis, George S. Labadie, Dale Laitinen, Arne Lindmark, Margaret M. Martin, Carl Vosburgh Miller, Aldryth Ockenga, Donald J. Phillips, Robert Sakson, Marilyn Simandle, Susanna Spann, Donald Stoltenberg, Warren Taylor, Jack Unruh, Janet B. Walsh, Frank Webb, William C. Wright.

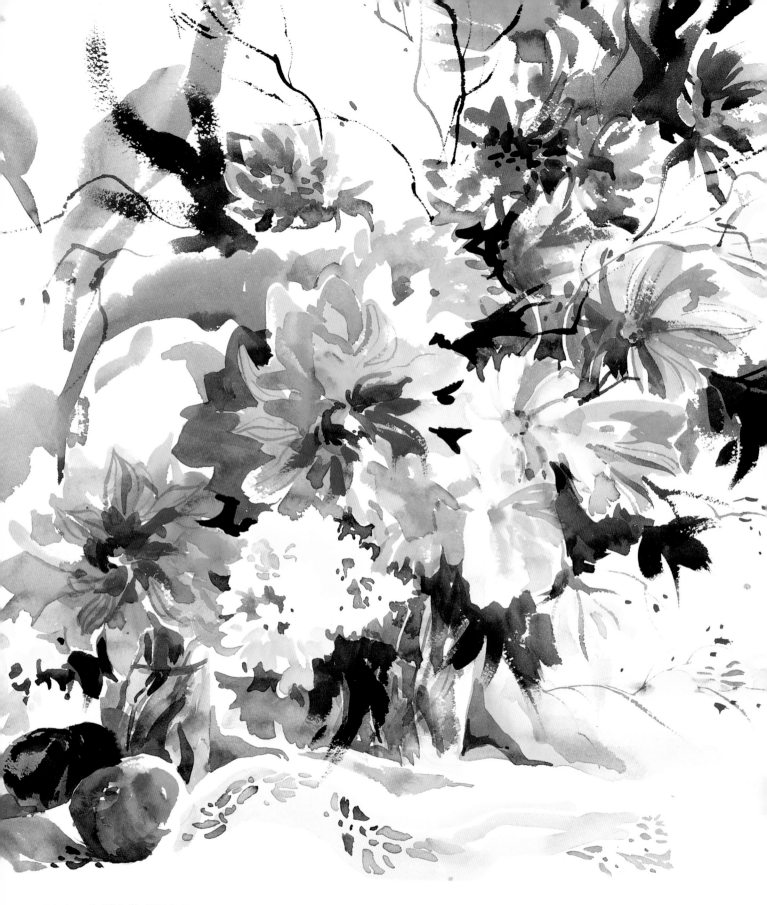

Maine Still Life With Lace

22" x 30"
Judi Wagner

CONTENTS

INTRODUCTION

Celebrating White in Watercolor

What is the real excitement of watercolor? What is in that visual feast that makes us want to create our own? Aside from the challenge of a medium that always surprises and delights, we believe the paper itself plays a very important role. It is the *paper* that shines through those beautiful transparent glazes we all aim for. It is the whites that make a watercolor painting sparkle.

In our first watercolor attempts, we try to force that perfect scene or subject onto the paper. We push paint around and worry about just how to render all those details. We are not aware of the paper itself and feel it is only something that needs "covering up." The more we paint, however, the more we become aware of how the untouched white paper communicates helpful suggestions to us—*if we just listen.* We don't *need* to cover everything with a layer of paint. And, because we have to think ahead in this one-shot medium, we become more aware of those whites we need to save. Our appreciation of that untouched paper grows.

We, the authors of this "ode to the white paper," put our ideas out there and asked thirty-three fellow watercolorists, painters, illustrators and graphic designers to share their experiences with white space, that is, the surfaces they work on. These contributions gave us a much wider-than-imagined range of explorations and findings. All of us hope that through this book we can share with you our love of, excitement about and experience with the paper surface. The quality and strength of this endeavor is the direct result of the fine painting examples submitted.

"Through art, mysterious bonds of understanding and of knowledge are established among men. They are the bonds of a great Brotherhood. Those who are of the Brotherhood know each other, and time and space cannot separate them."

—ROBERT HENRI

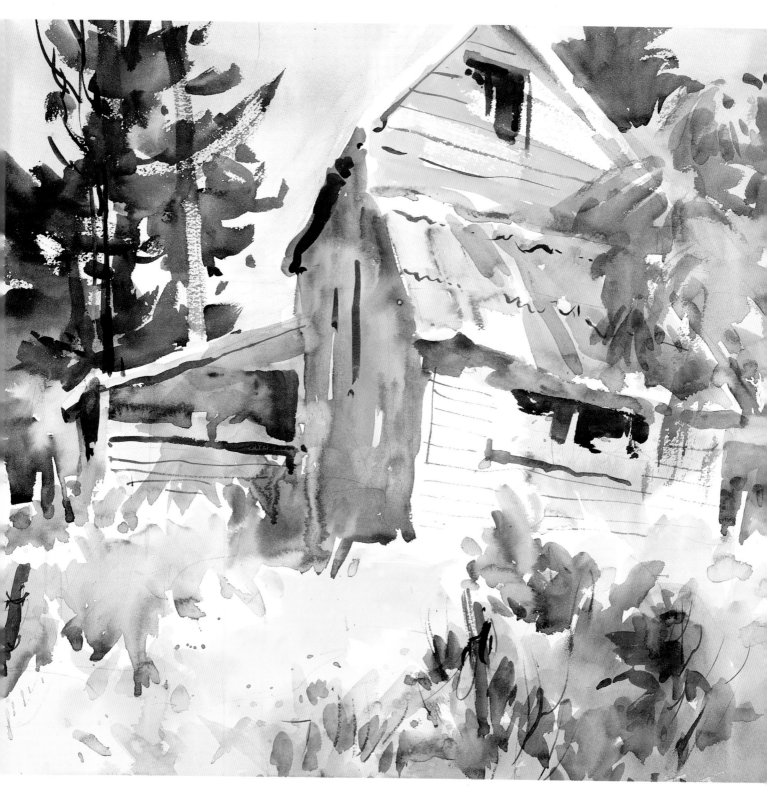

The Shackford Place

22" x 30"
Judi Wagner

CHAPTER ONE

Create an Eye-catching Design That Sparkles

When faced with the questions "What do I paint today? What do I find inspiring?" we find answers in our love of nature and the jolt of a good design. *Spanish Facade* offers creative ideas through its use of beautiful lights that create inspiring shapes and add to the strong graphic shape of the vignette. The sparkling whites integrate with the painted surface to entertain.

"For whom does one paint? For oneself. The painter must fulfill his own needs and must meet his own private standards."

—BEN SHAHN

Spanish Facade

22" x 30"
Tony van Hasselt
Tony van Hasselt generally works on
140-lb. Arches cold-press paper, but
he experiments with other papers.

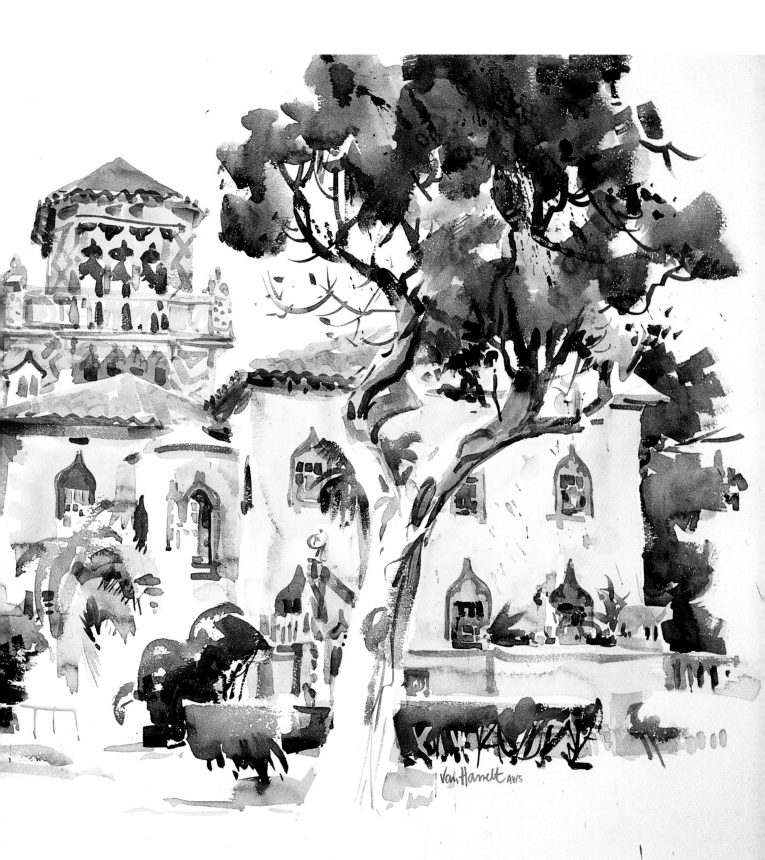

3

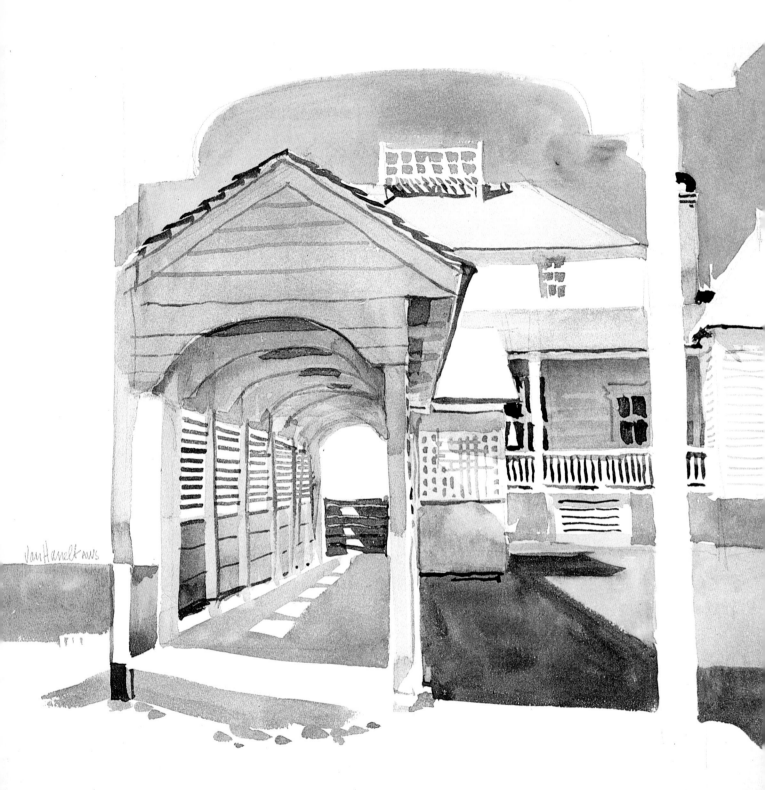

Plantation Geometric

15" x 22"
Tony van Hasselt
Instead of telling the full story of the
plantation, Tony focuses the subject on
one idea by designing shapes within the
covered walkways.

Simplifying Your Subject

The *prime* challenge in creating a visual theme is keeping your idea
simple, that is, making a direct, easy-to-read statement. By using
white shapes in a watercolor, you eliminate unnecessary subject mat-
ter and detail and allow the shapes to do more of the work, getting
right to the heart of your thought or idea.

"In the course of a painter's life the
decisions are always to exclude.
The very act of painting is an act of
exclusion. A painter cannot take in
all the particulars of a teeming
world."

—DORÉ ASHTON ABOUT ROBERT
MOTHERWELL

Philip Jamison

"I think *Vinalhaven Bouquets* shows my use of white paper as well as any works I have done. It is small and simple, which has been my direction. Although I believe color is very important in any work, I am not a 'colorist.' I think basically in black and white, and I run the gamut in most every painting. Letting white be the white of the paper makes for a cleaner, more sparkling watercolor. The kinds of paper I use depend upon my subject and materials—watercolor, pencil, charcoal, gouache and oil paints—all of which I often use in my watercolor paintings."

Vinalhaven Bouquets

9" x 11"
Philip Jamison
Philip Jamison uses many different
kinds of paper, depending on the subject
and the medium.

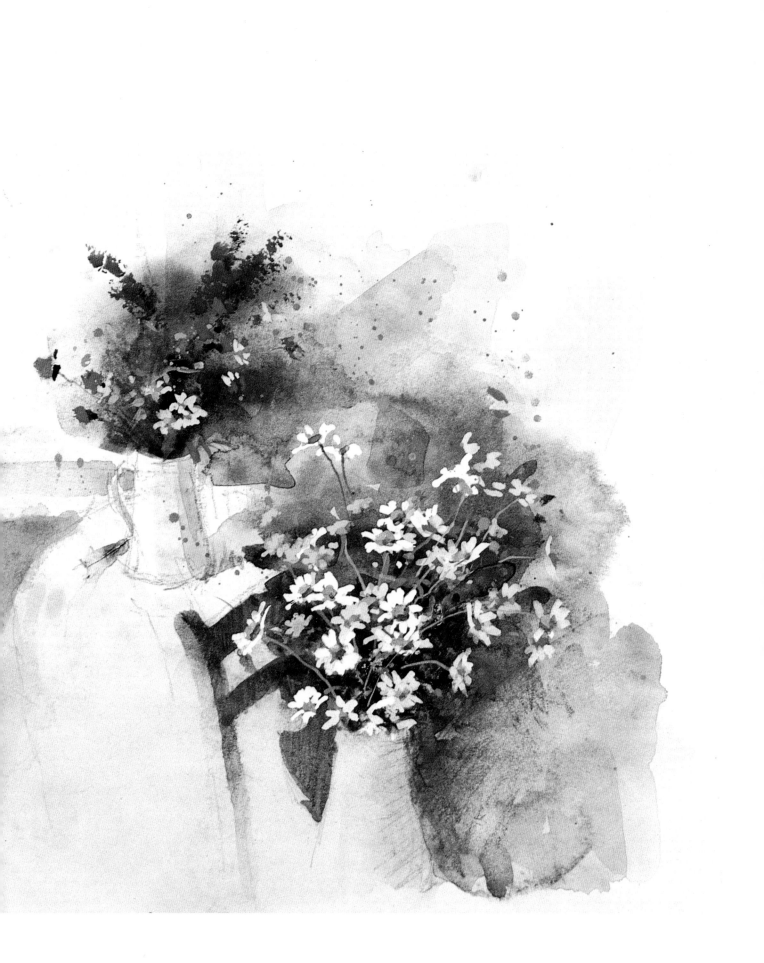

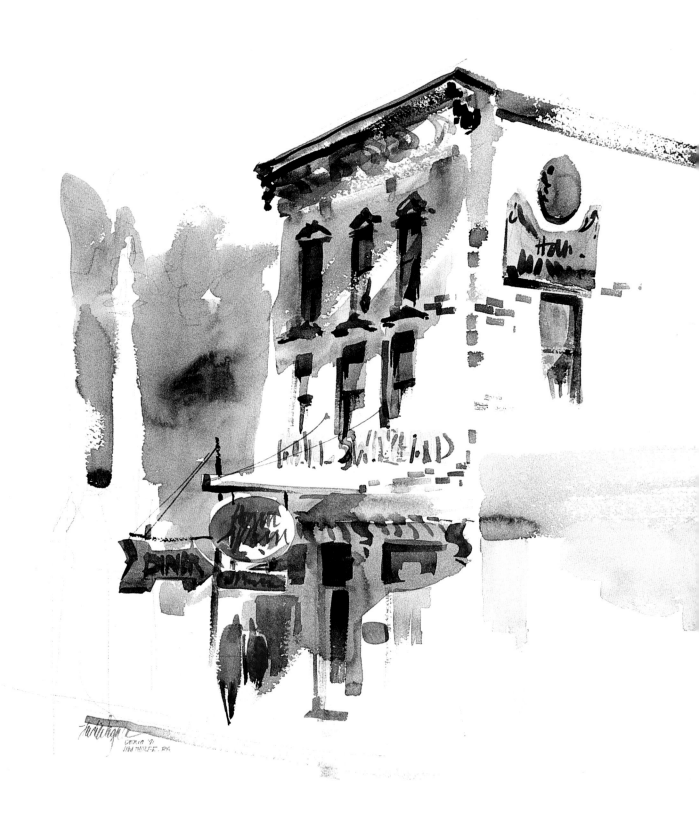

Jim Thorpe Hotel uses the fewest symbols and shapes to tell the story. This hotel/restaurant is designed against the green foliage bank, with the statue of a former hero. By not showing the rest of the street and details, the artist proves that less is more. The white shapes interlock with the subject matter to tell their own story. This is an example of placing subject matter in a creative design.

"Express the essence with symbols."

—EDGAR A. WHITNEY

Jim Thorpe Hotel

22" x 30"
Judi Wagner
Wagner generally uses 140-lb. Arches cold-press paper, but she experiments with other types of paper.

Using Positive and Negative White Shapes

In *Boca Grande Lighthouse*, the palm trees change from positive to negative and disappear into palm-frond shapes of white that are expressed negatively by the blue sky wash. This push and pull of positive and negative sets up an artful use of shapes throughout, especially in the roof, sand and boat. These white paper shapes express the strong southern sunshine.

"Freedom itself is a disciplined thing. Craft is that discipline which frees the spirit; style is the result."

—BEN SHAHN

Boca Grande Lighthouse

22" x 30"
Tony van Hasselt

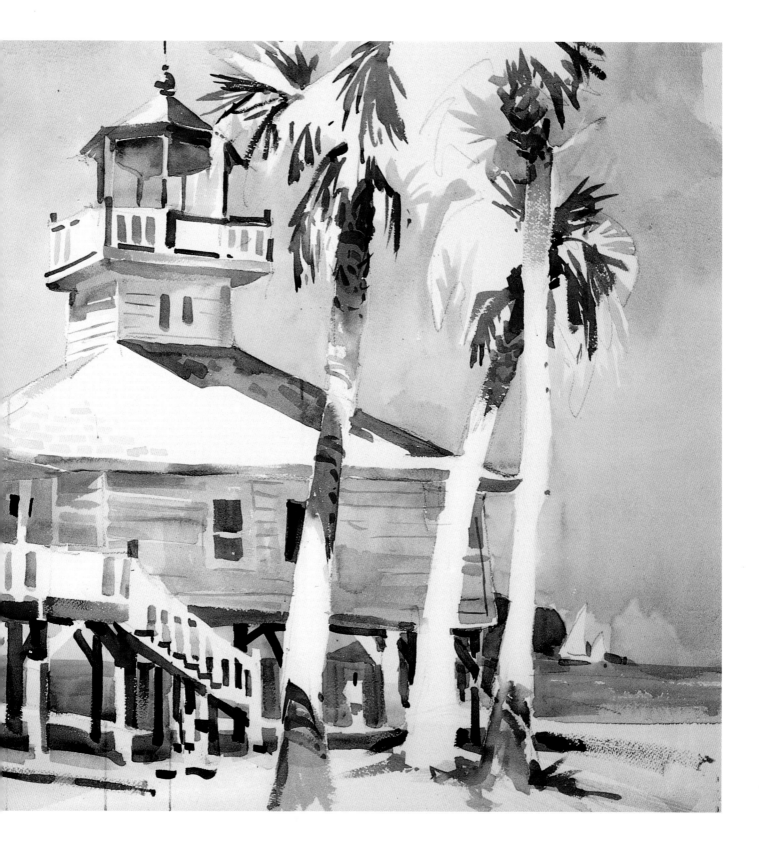

Rex Brandt

"*Lerici* is based on a sketch made on a trip to Italy; it uses gradation, passage and white paper. The illusion of passage has been described as lost and found edges; what the losing does is help to return the mind's eye to the unity of the paper. A watercolor is white paper with marks on it, just like a sculpture is a piece of marble with holes in it."

"I enjoy pictures that say what they have to say, simply, directly and seemingly with little labored effort."
—MILFORD ZORNES

Lerici

26" x 18"
Rex Brandt
Rex Brandt generally uses 140-lb. Arches (Torchon). For working vertically, he prefers Saunders papers.

WHITE PAPER SERIES
- Lucca
Fulvio Bianchi NA
3-9-92

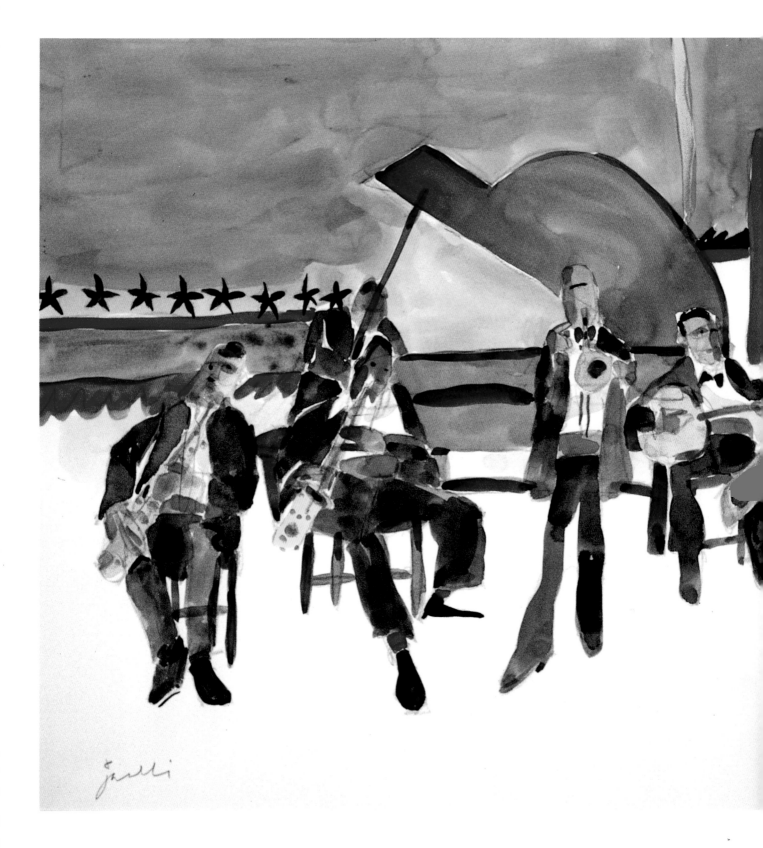

Zygmund S. Jankowski

"Negative is positive, positives are negatives; the choice of value depends on juxtaposition, content and self-interest."

The interestingly exaggerated shapes of the musicians' legs, surrounded by carefully designed whites, make *Musicians* a fine example of interplay among positive and negative shapes.

"I think one creates mood in a picture the same way it is done with music. The rhythm in music, the major key or the minor key, has its similarity in art. If you want to create a picture which is strong and powerful and gives a mood of great strength, you pull out all the stops and the masses will be big and strong and contrasted."

—OGDEN M. PLEISSNER

Musicians

22" x 30"
Zygmund S. Jankowski
Jankowski has no paper preference and uses all types.

Connecting White Shapes

When white paper and light values are connected to one another, these individual shapes take on an additional importance by becoming whole new shapes that assist the flow of the eye through the composition.

Frank Webb "Except for the whites, a light blue 'mother-color' wash covers the entire paper in *Lake Marina*. After this wash dried, darker washes were superimposed. This procedure guaranteed sparkle—all washes were deliberately flat and hard edged, so the whites were also left flat and hard edged."

Lake Marina

15" x 22"
Frank Webb
Webb uses Arches or Winsor & Newton papers.

Green Gables Inn

22" x 30"
George Kountoupis
Kountoupis prefers 140- and 300-lb.
Arches cold-press paper.

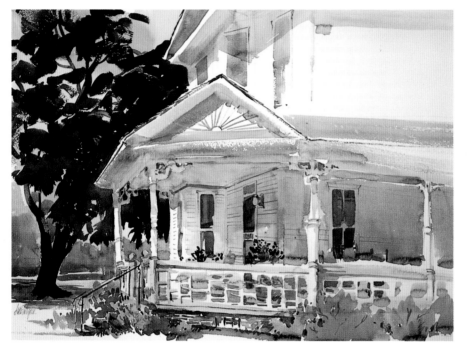

Where's Mr. Askins?

22" x 30"
Judi Wagner

"A good painting is a remarkable feat of organization. Every part of it is wonderful in itself because it seems so alive in its share in the making of the unity of the whole, and the whole is so definitely one thing."

—ROBERT HENRI

Letting Sparkles of White Tell the Story

In *On the Back Porch*, the tropical sun swallows up values and colors, but incised shapes tell the story of this utility porch filled with all types of treasures. Leaving white shapes to do the work creates the action and sparkle of the sun.

Clear communication happens when the sparkle of white acts like a loud clapping of hands—it draws attention by setting ideas apart and punctuating visual thought.

"It was said that Winslow Homer used open areas of untouched paper to convey lights on water and other light-struck areas."

—JOHN WILMERDING ABOUT WINSLOW HOMER

On the Back Porch

22" x 30"
Judi Wagner

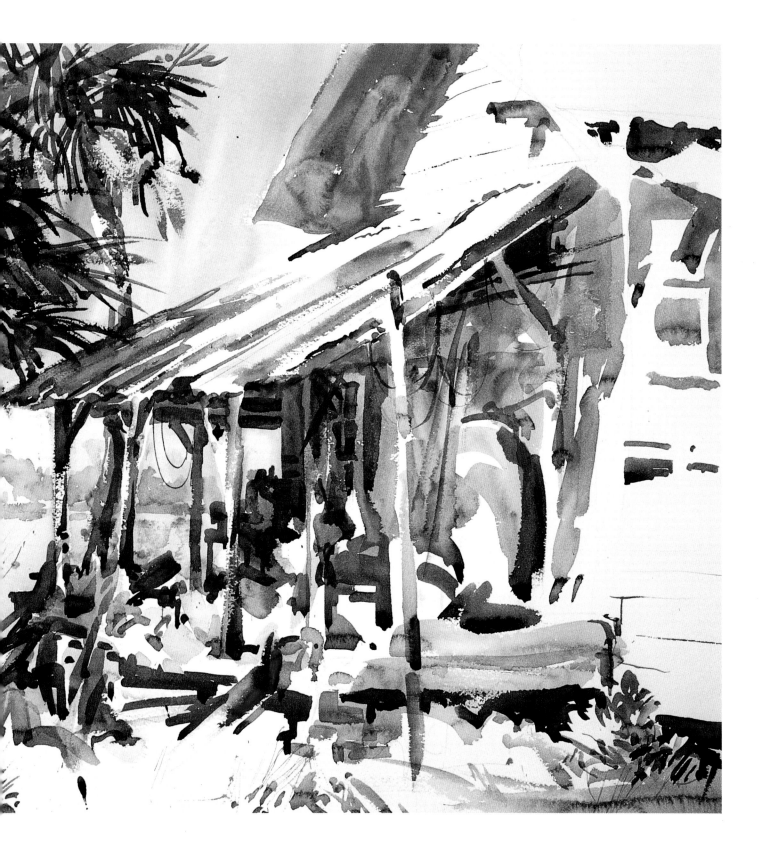

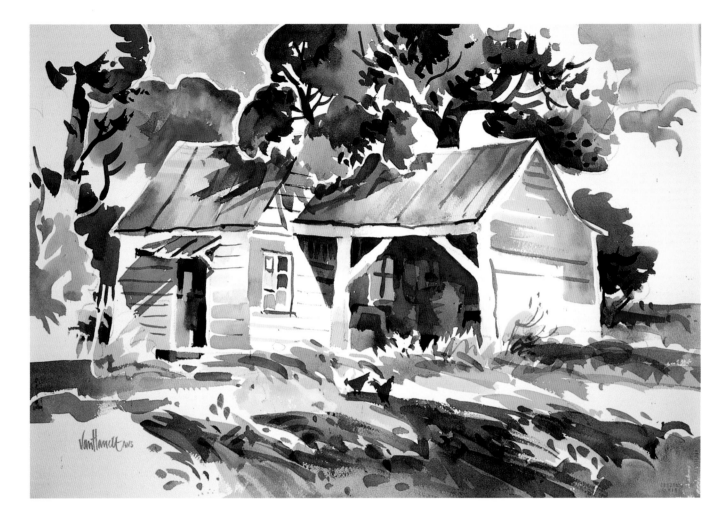

The Potting Shed was done as a student exercise promoting the use of opposite, or complementary, colors. Because white spaces have been left between colors, the eye is treated to a new visual experience and interpretation of an ordinary landscape theme. The tension of opposite colors adds extra punch to the carefully thought-out design.

The Potting Shed
15" x 22"
Tony van Hasselt

"Nature is really very messy. It's an artist's job to straighten it out."

—DONG KINGMAN

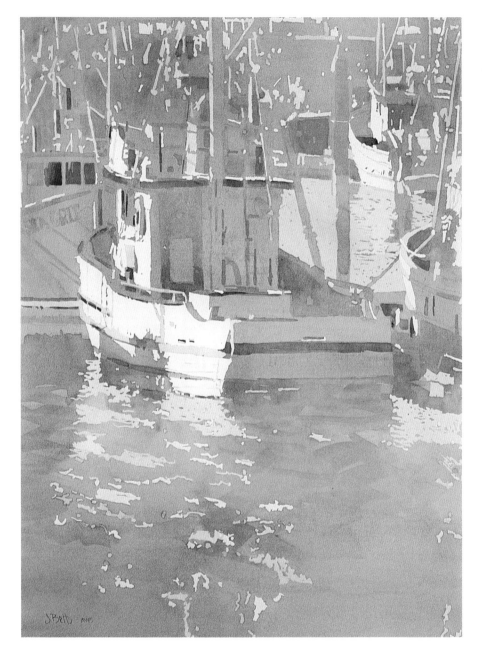

Sea-Esta

30" x 22"
Judi Betts
Collection of C. Robert Potter
Betts uses a variety of papers, but most frequently Arches 140-lb. cold-press.

It is hard to imagine *Sea-Esta* working so effectively without the carefully chosen whites that are repeated in the harbor reflections. Judi Betts says, "I see my world in black and white. I like the contrasts of sunlight and shadow. I don't start a painting unless I can see the whites, see them as magical shapes in my painting. Often I exaggerate them. I feel I can always get rid of the whites."

Arne Lindmark underpaints *Dockside IV* and most of his paintings with acrylics for future glazing. Yet he leaves large areas of pure white paper to help tell the story. He explains, "I do a value sketch in black and white, from dark to light. I let white shapes happen. If the darks work, the lights should also."

Dockside IV

22" x 30"
Arne Lindmark
Courtesy Heritage Gallery, Poughkeepsie, NY
Lindmark uses Fabriano hand-made rough paper.

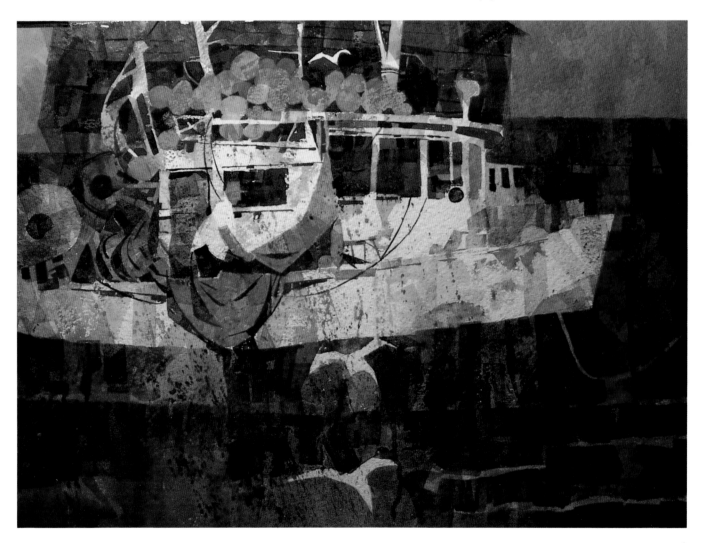

Dan Burt lets the whites tell their story with a different technique: "I paint around saved whites with pure, clean, transparent colors instead of earth colors. I usually display a large dark shape and small light shapes against a middle-value shape. I like to treat most of the dark and middle-value shapes in a wet-in-wet manner and keep hard edges in other areas, especially in and around the focal point. At this point, I also display the highest chroma color with its opposite and save a white with the darkest area next to it."

"The most beautiful Art is the Art which is freest from the demands of convention, which has a law to itself, which as technique is a creation of a special need."
—ROBERT HENRI

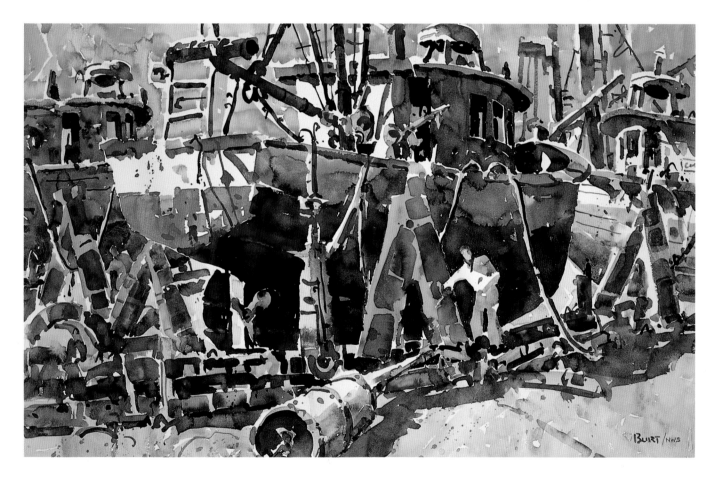

Big Sister

25½" x 40½"
Dan Burt
Burt uses mostly Arches 140- or 300-lb. cold-press paper, but he sometimes uses Arches 140-lb. hot-press.

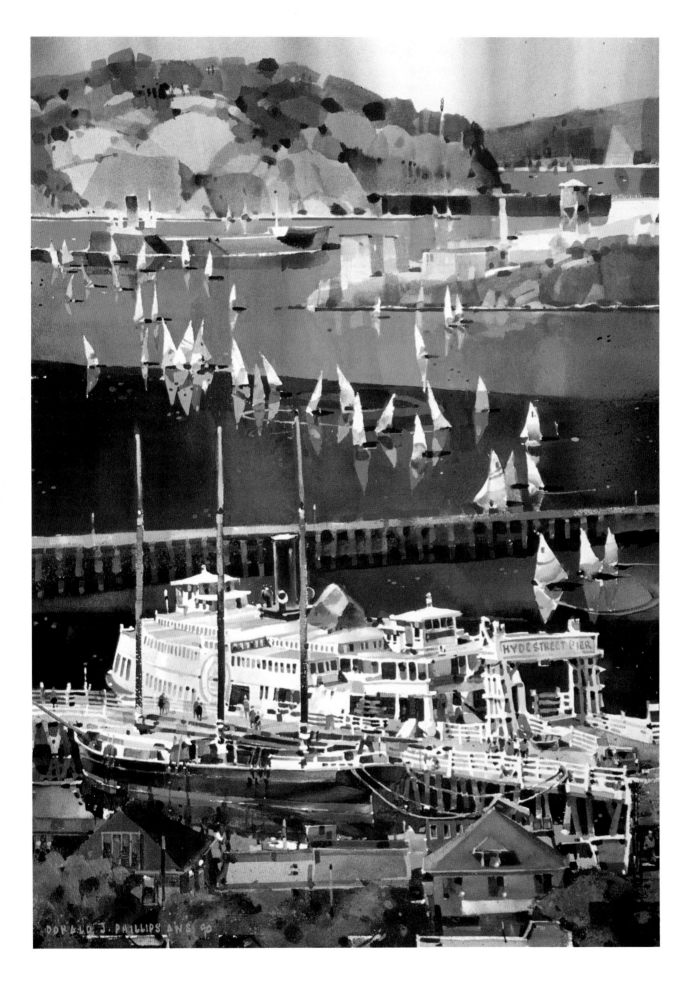

Hyde St. Pier

28" x 20"
Donald J. Phillips
Courtesy Fireside Gallery, Carmel, CA
Phillips uses a variety of papers, but he generally uses Arches 300-lb. rough.

Planning Pathways In and Out

Donald J. Phillips "I hold paper whites foremost in mind. If they are lost, they are gone forever. The use of masking agents creates hard or mechanical edges and is not consistent with the painterly style of watercolor. When I sketch, I plan my light-and-dark pattern from white paper to my darkest dark, and I hold onto these islands of white to the end. If they become too numerous or create a spotty pattern, I can soften some with a wash or just kill them off."

In *Hyde St. Pier*, the viewer is artfully led by whites down to the water and across the bay to the land beyond.

In *Flowers and Chicken*, the whites are directing the viewer's eye through the still life and around the entertaining shapes.

Flowers and Chicken

22" x 30"
Judi Wagner

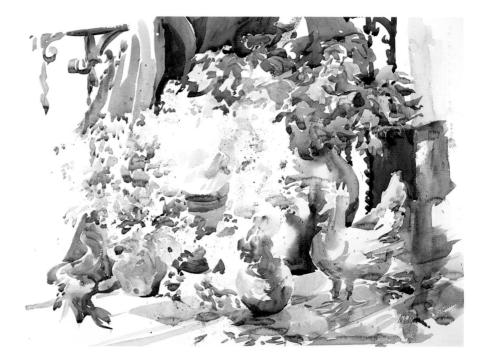

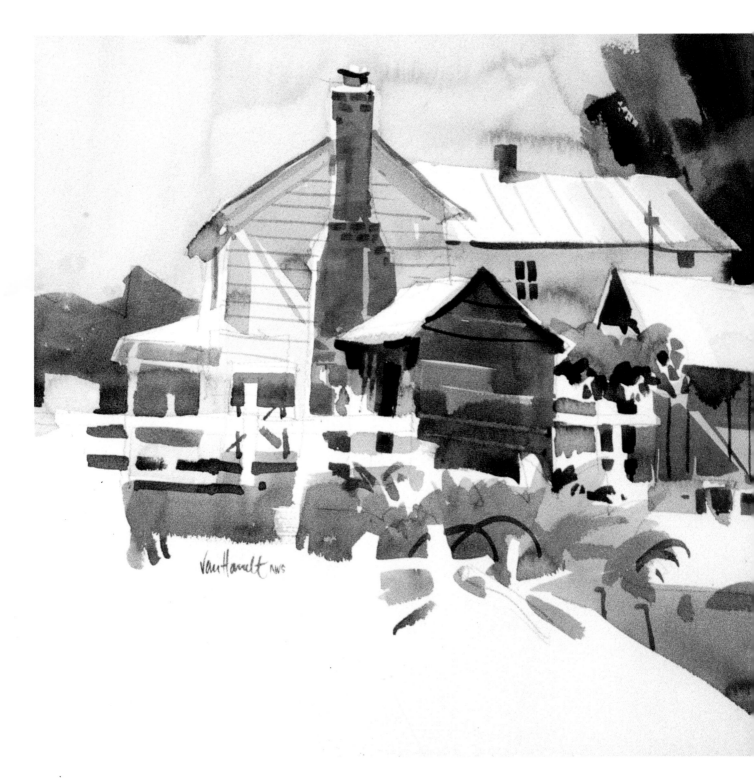

Waynesboro Farm

15" x 22"
Tony van Hasselt

Although the foreground of this subject contained a complicated array of farm equipment and boards, these shapes were only suggested with the edge of the green grass shape. By this careful elimination, a wonderful white shape is created with edges that interlock into the painted areas. The subject is the grouping of buildings, *not* the foreground.

Exploring Vignettes

When queried about why his vignettes were priced the same as his completed works that were painted all the way to the edge, Claude Croney gave the perfect reply: "Sir, you are paying me for restraint."

We like to think of vignettes as "spot" illustrations. The designed *shape* of this *spot of paint*, however, is as important as the design of the untouched white paper surrounding it. With the vignette, we really tend to zero in on the subject. When this is not done, superfluous detail asks to be included and, before we know it, we have painted right up to the edge of the paper and lost that vignette quality.

The mental editing of the scene is most important. We must ask, "What is the subject here and how will I make that transformation from the painted edge into the white of the paper?" The trick is to keep the eye on the subject while the white is the silent supporting actor, without which the play (the subject) would fail.

Over the years, a number of vignette rules have evolved. However, most of the chosen examples in this section would not live up to those rules. Instead, let us enjoy the interplay of subject with the creative use of white space, the interlocking masses of subject matter and untouched paper.

The question is: Where to touch the edge of the paper? And how much of the paper to leave untouched? How large to make the featured subject ... the "star-to-stage" relationship of the size of the paper versus the subject? White paper can bring life and sparkle to a dull subject, or simplify a busy, complicated scene, while directing our eye to a specific thing, such as a person, shape, mood or feeling.

"A vignette is a piece of subject matter in a well-designed piece of white space."

—EDGAR A. WHITNEY

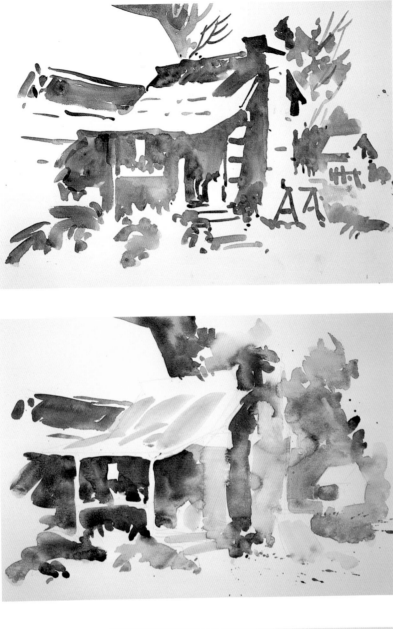

Step 1

Before attempting a vignette rendering, I need to feel out the size of the subject versus the size of the paper. Where will I place my painted areas, and how will I design the remaining whites? To get an idea, I *paint* my sketch on a good quality, smooth-finished drawing paper, in the same size as the actual painting. I concentrate on the patterns of darks and transitions from the touched areas into the untouched paper areas.

Step 2

Since I want to create a warm feeling to the painting, I select 140-lb. Bockingford Oatmeal paper, which is cream-colored. After a basic pencil sketch is made, I loosely apply light base tones, letting them mingle wet-into-wet with slight value and color variety to keep each area interesting. My eye adjusts to the tinted paper as if it were white. Notice that the highlight in the doorway, surrounded by darks, appears white.

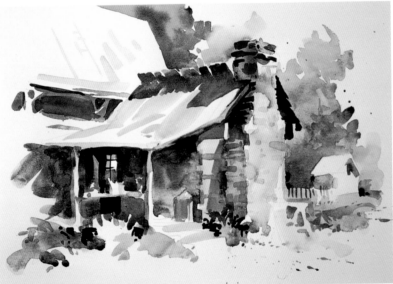

Step 3

In this phase, I sharpen shadows, add cast shadows and paint in the dark areas, using my pattern sketch as a guide. In addition, brick textures are added to the chimney, and the background-grass delineation is established with the indication of a distant fence.

Tony van Hasselt says, "Now that Bockingford watercolor papers are available in tinted versions, I thought it would be interesting to see how a vignette, usually done on white paper, appears on a cream-colored sheet. While painting this demonstration, I related to the tinted paper as being white. Next time, however, I plan to add some actual white paint for contrast. I find that using this tinted paper is a great way to establish a 'mother color' and set a mood for the selected scene."

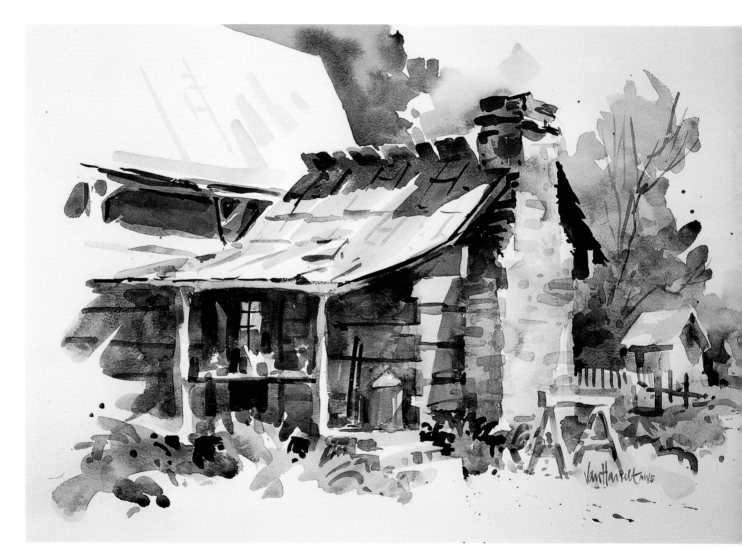

Step 4

Final touches are added with a smaller brush and darker values. Details in the porch are firmed up and the front end of the sawhorse is added, as well as some distant tree forms. A value adjustment is made to the little shed since it seemed to draw a bit too much attention to itself. Chinese white or white acrylic paint could be used for some of the highlights, but it isn't really necessary. I like the warm feeling of the subject on this paper.

The Pioneer Homestead

15" x 22"
Tony van Hasselt

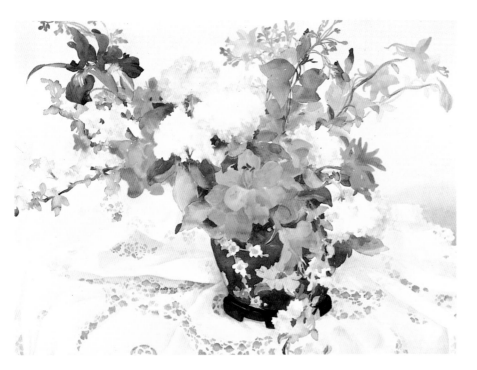

China Blue

22" x 30"
Janet B. Walsh
Walsh uses a variety of papers such
as Fabriano 140-lb., Gemini 300-lb. and
Lanaquarelle. In this vignette, the spots of
brilliant color are well balanced and echoed,
while the white paper wraps around and
into the subject. Note the curvilinear
rhythms established by the twigs and
repeated in the lace patterns of the table-
cloth.

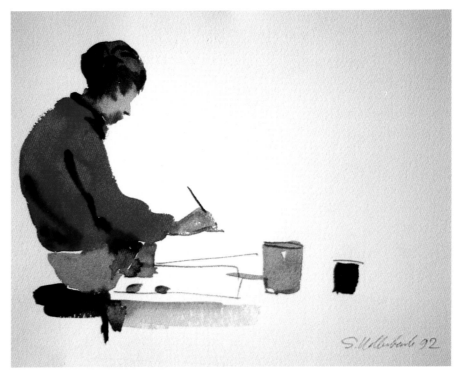

Workshop Sketch 2

11" x 14"
Serge Hollerbach
Hollerbach uses 140-lb. Arches cold-press paper. In this vignette—a charmingly direct sketch
of an artist in action—note the important balance established by the two rectangular shapes
on the right.

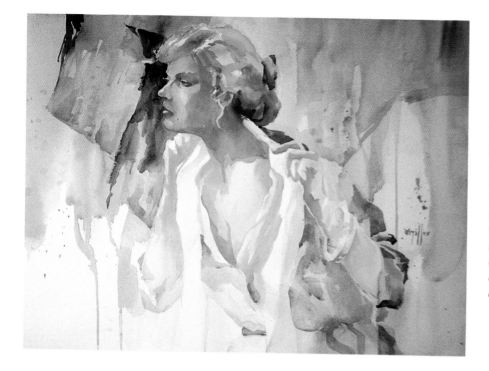

Cari

22" x 30"
Carl Vosburgh Miller
Miller uses mostly 140-lb. Arches; also Winsor & Newton and Indian Village papers. Here, the whites interlock into the vignetted subject and background. Our attention is *forced* to the face, where the darkest dark and hardest edge quality are displayed by using two complementary colors.

Virginia

30" x 22"
Jackie Brooks
Jackie Brooks uses a variety of papers such as 140- and 300-lb. Arches hot- and cold-press, 140-lb. Lanaquarelle hot- and cold-press, Bainbridge illustration board hot-press and Utrecht 140-lb. hot- and cold-press. The whites and spots of color are beautifully linked and distributed over the page and eventually lead the eye to the face in this vignette.

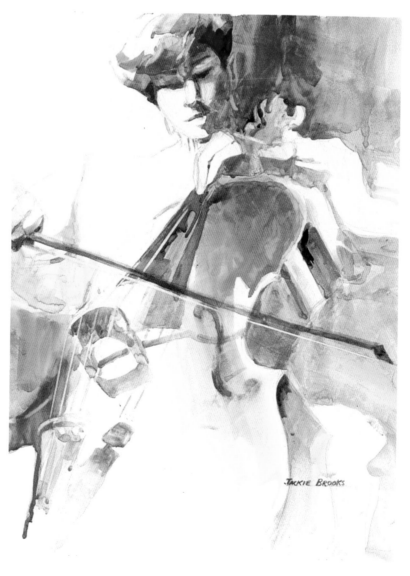

Blue Ridge Church

15" x 22"
Tony van Hasselt
Since a vignette is surrounded by white paper, a white structure in sunlight is not an ideal subject to choose for vignette treatment because it is easy to create a "spotty" feeling. Here, the strong foreground cast shadow, as it falls onto the front of the church, helps to tie the spots together.

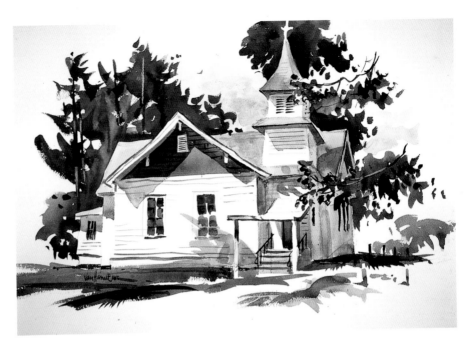

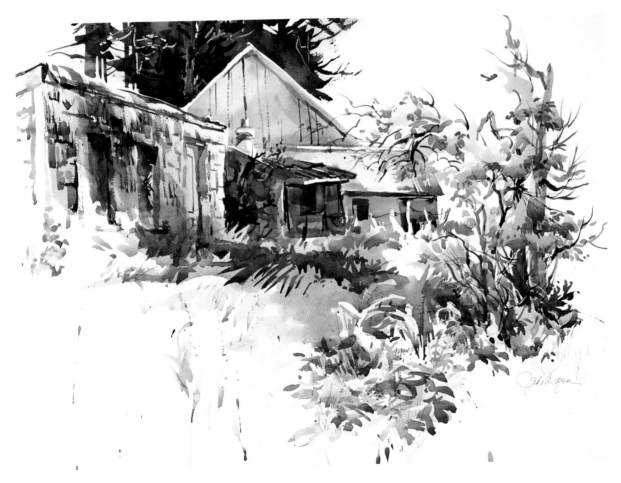

Shackford Vignette

22" x 30"
Judi Wagner

In this scene of barn structures, the subjects are linked together as one total painted shape that touches the edges in three well-chosen areas. The untouched white paper shapes in all four corners are different weights. These are some of the things to consider when creating a vignette.

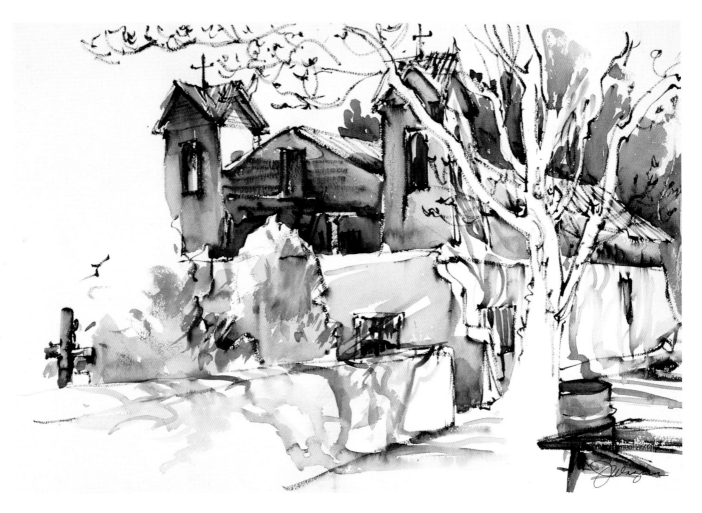

Sanctuario Vignette

15" x 22"
Judi Wagner

This vignette exploration started as a brush drawing. Color was woven through the drawing to tie the subject together. The limited color variations also help to unify this subject.

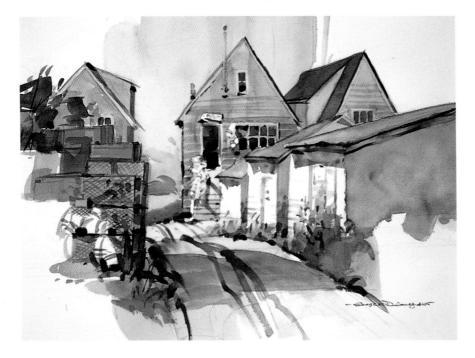

Monhegan Road

15" x 21"
George W. Delaney
Delaney uses Arches and Winsor & Newton hot- and cold-press papers. This subject is surrounded by beautifully designed white areas, each one measuring a different weight. The large foreground shadow ties the composition together in an almost checkerboard fashion from left to right.

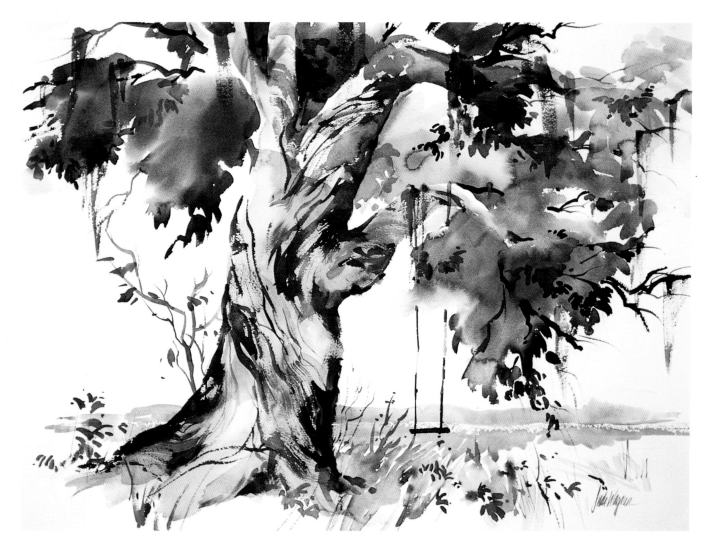

Framing the Subject With Whites

When the subject is surrounded by white, not necessarily a vignette, as in *View of the River*, there seems to be no reason to molest the simplicity of the background or to challenge the emphasis of the tree's entertaining bark.

View of the River

22" x 30"
Judi Wagner

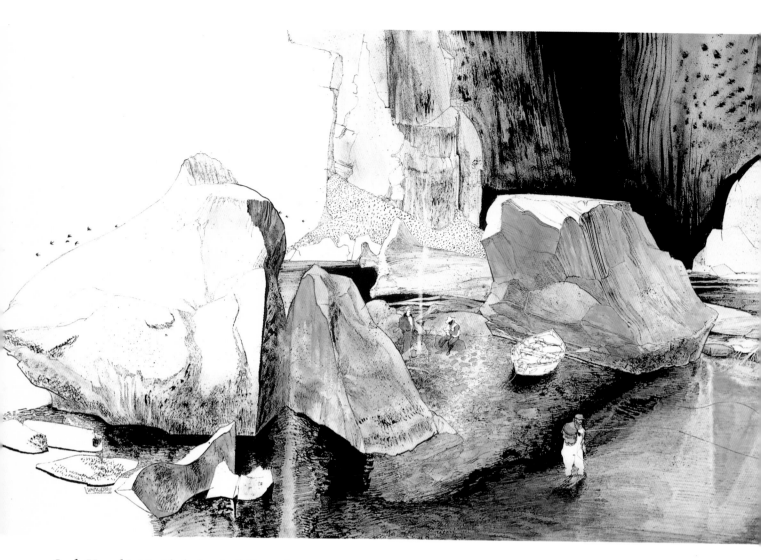

Jack Unruh's Untitled *clearly follows his quote: "My approach to white paper has just developed—pushing the design structure of the illustration." Equal strength and importance is found in the surrounding white as in the subject matter itself. It is interesting to note the similarity of the design structure between this painting and* View of the River. *As in Shakespeare, the play or the design is the thing. When the whites support and hold together, the actual subject matter is right and complete.*

Untitled

15" x 24"
Jack Unruh
Unruh uses Strathmore illustration board,
100-percent rag, cold-press.

Leading the Eye to the Center of Interest

When whites are artfully placed, the eye is led into the star of the composition. The artist uses whites to control and set up the mood and the discussion within the work.

Donald Stoltenberg's *Three Bridges* leads our eye right in on the tracks under the trestle to the center of interest. He states, "I always leave some white in its pure state—I sponge away color in places to reveal paper. Sometimes I use Chinese white to heighten or contrast whites."

"The eye should not be led where there is nothing to see."

—ROBERT HENRI

Three Bridges

20" x 26"
Donald Stoltenberg
Stoltenberg uses Arches papers exclusively.

Asilomar Remembered

22" x 30"
Arne Lindmark

Dock at the Lake

15" x 22"
Tony van Hasselt

In *Asilomar Remembered*, a masterful gradation leads our eye along the path to the figures, where the lightest lights are displayed against the darkest darks. Note that the most colorful pieces of paint are also placed in this focal-point area.

In *Dock at the Lake*, the whites lead us directly up and onto the dock. With careful planning of these white shapes, the eye is properly directed; the clouds balance the whites of the foreground.

In *Deadman's Cove*, the rock shapes in the foreground lead the eye up and to the porch, and then beyond to the cottage across the cove. Linear and triangular light shapes dominate the eye's active path.

When the tide recedes in *Little River, Low Tide*, the path to the ocean is clearly marked with a reflective water surface of lights among the seaweed-covered rocks. The distant, small island takes on importance as the center of interest.

"There is no bad or overworked subject—only poor, tired and overworked approaches to the subject. Take the corniest idea, paint it with a fresh eye and with emotion and conviction, and you will make a piece of art."

—WILLIAM F. REESE

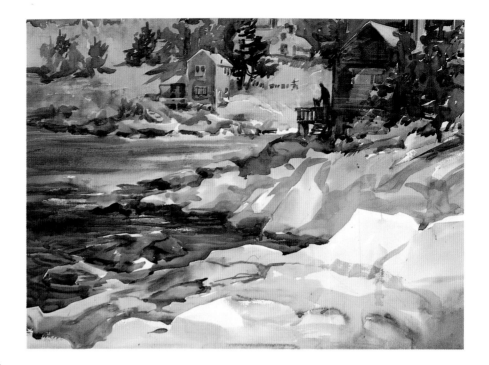

Deadman's Cove

22" x 30"
Judi Wagner

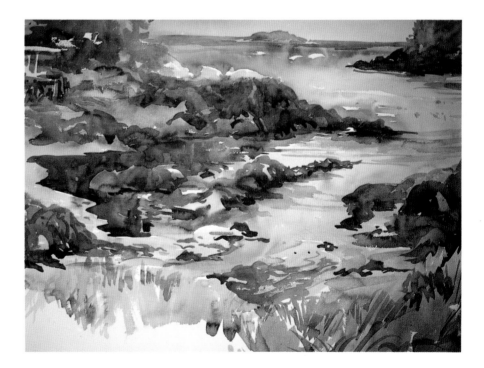

Little River, Low Tide

22" x 30"
Judi Wagner

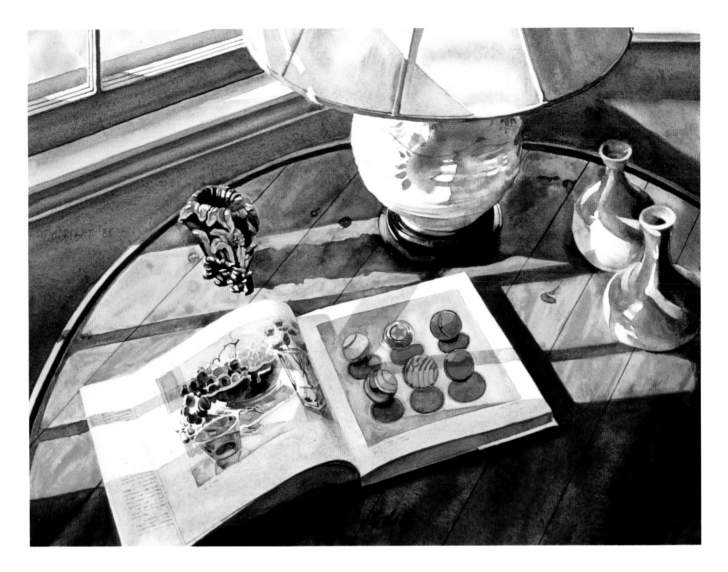

January Slant

12" x 16"
William C. Wright
Wright uses 140- or 300-lb. Arches hot- or
cold-press papers.

Expressing the Focal Point With Whites

With the light source coming through the window in *January Slant*, the eye is led to the focal point—the whites of the book's pages. We notice other objects on the table also, but the eye comes back to the white pages, where the artist has displayed the purest and most colorful bits of paint. William Wright says, "I plan for the white areas carefully with a detailed drawing. I then paint around them, working in a traditional watercolor manner, using light value colors and washes first, followed by darker colors."

"Art is full of contradictions."

—CHEN CHI

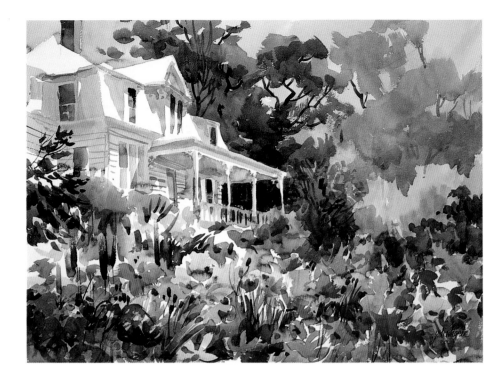

Anderson's Poppies

22" x 30"
Judi Wagner

In *Anderson's Poppies*, the flowers, being the most colorful element, attract a lot of attention. Their secondary purpose, however, is to lead the eye to those beautifully shaped whites of Mr. Anderson's colonial structure.

The lightest light in *Path to Big Sur Beach* is perfectly placed for the center of interest and is in strong contrast to the tunnel-like dark trees. The stage is set, and the two figures on the beach add scale and interest.

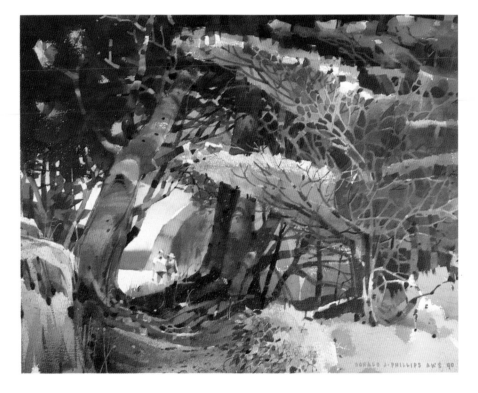

Path to Big Sur Beach

20" x 28"
Donald J. Phillips
Collection of Richard Barrett

CHAPTER TWO

Use Values to Add Visual Effects

George S. Labadie

"White paper plays many roles for me—from the focal point of dramatic contrast to building luminosity through layering of glazes where the reflective qualities of pure white paper take advantage of pigment transparency."

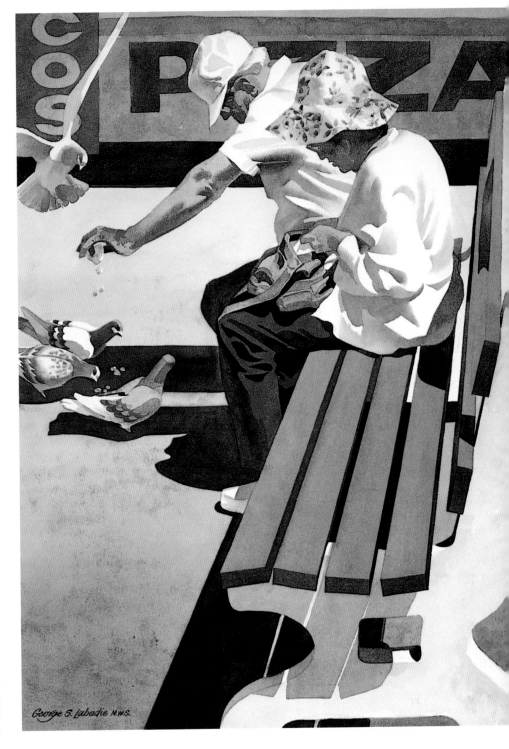

Lunch Break

30" x 22"
George S. Labadie
George Labadie paints mostly on
140- and 300-lb. Arches hot-press and
cold-press papers.

Mature Bassist

24" x 18"
Jackie Brooks

Jackie Brooks

"I first do a preliminary value study and make decisions about where the whites will be. I often place the darks next to them for emphasis and drama. I use masking agents sparingly so I can keep the work loose. Sometimes when I lose a white, I find I can lift color out with a stencil cut from frosted Mylar or with a short bristled brush dipped in water, followed by dabbing with a towel. For some paintings, I leave a large amount of white."

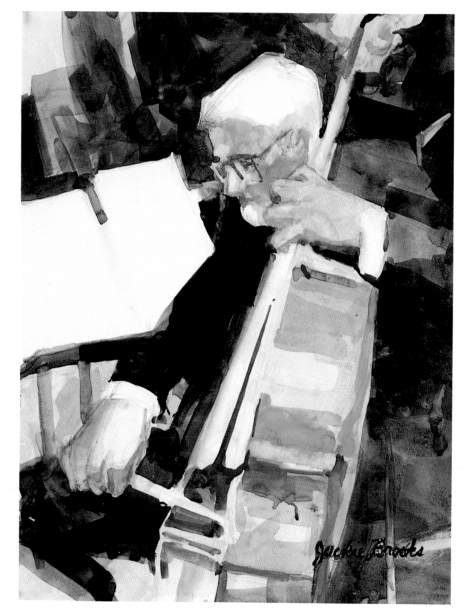

"Light is everything in the visual arts. Without it these arts could not exist. The artist controls light intensity with values, changes its colors with pigments and thereby creates his effects. Like all animals, we are extremely sensitive to light, and any change in its intensity affects us strongly. Sunlight stimulates, twilight calms and makes pensive, and darkness depresses with fear and mystery. These are universal reactions to light and are as ancient as Adam."

—MAITLAND GRAVES

Step 1

The drawing was done at a stand of holly-hocks that caught my attention in the brilliant morning light against a dark background. I pulled up my stool and easel to a position almost inside the tall stalks. I concentrated on the best-lit blossoms and made up my own background.

Step 2

With a 6B pencil I drew the image on Arches 140-lb. cold-press paper, then sprayed clean water on the entire sheet. Starting with a 2-inch brush, I planned to save some "special" whites—there is no white as dynamic as the original paper. It was important to paint carefully where care matters and casually elsewhere. When I was satisfied with this phase, I stopped and let the image dry.

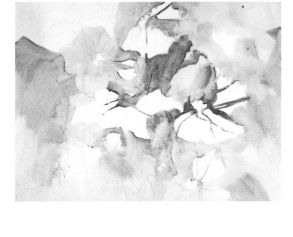

Step 3

Next, the middle values were added. They provided a foil to bring out the initial washes on the blossoms. These midvalue shapes are warmer than the first wash and give a much-needed, warm-cool contrast to the painting. I put in a dark so I could see where to go with the darkest values.

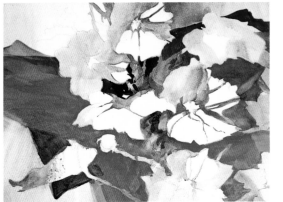

Step 4

It was time to put in the rich darks along the path of the stalk. The two buds were rendered with neutral color.

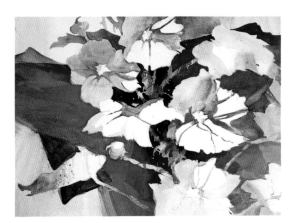

Sunlit Hollyhocks

22" x 30"
Carl Vosburgh
Miller

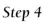

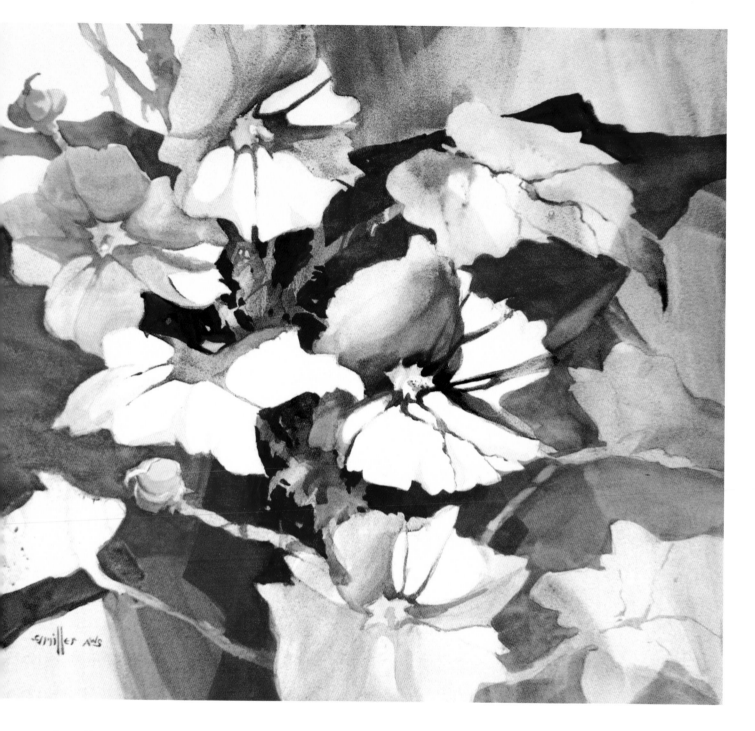

Step 5

In this finishing phase, the value in some parts of the blossoms was adjusted, a warm glow was added to the main blossom (right center), and a few dark accents were put in.

Carl Vosburgh Miller

"I am a practicing transparent watercolorist. I go to great lengths to save pure white paper because that is a value you can never get back. White paper is a value unto itself. It is the charm of watercolor. Saved whites can become very special in a painting."

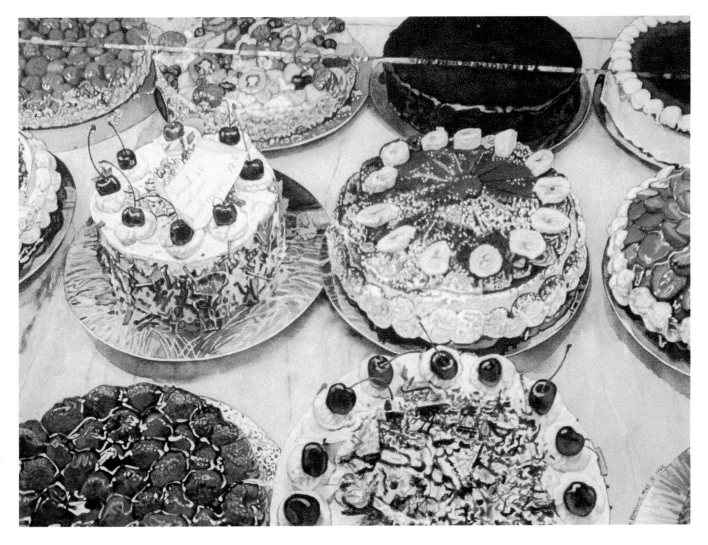

Creating Rhythmic Accents

Rhythmic accents or patterns are amplified when the whites are artfully shaped and placed, as shown in the paintings on these pages. The casual observer is not aware of these accents. The dutiful copier of a scene is unaware. These rhythmic accents are superimposed onto the subject by careful planning. They can be clearly distinguished and held onto during the painting process by painting and observing with half-closed eyes.

Marilyn Edmonds "My paper is beautiful and seductive. It is the only white on my palette. I always need white for value contrast. Typically my paintings 'glow'—the white paper helps that happen ... it's a means to the end."

Just Desserts

22" x 30"
Marilyn Edmonds
Edmonds uses 300- and 400-lb. Arches cold-press papers.

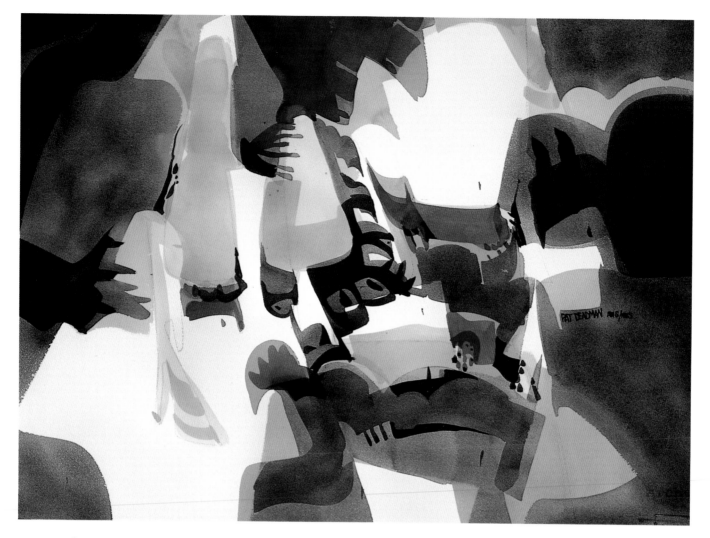

Pat Deadman "White paper is the vital part of a fresh and exciting watercolor. I plan around the white, preserving it for special emphasis, and depend on color and design to support and enhance the whites."

Pattern Series

22" x 30"
Pat Deadman
Deadman uses 140-lb. Arches cold-press paper.

"Notice first how rhythmically the

abstract elements are arranged,

then with what sensitivity their

equilibrium is maintained, and

finally, how they impact on the

subject itself."

—THOMAS S. BUECHNER ABOUT

OGDEN PLEISSNER

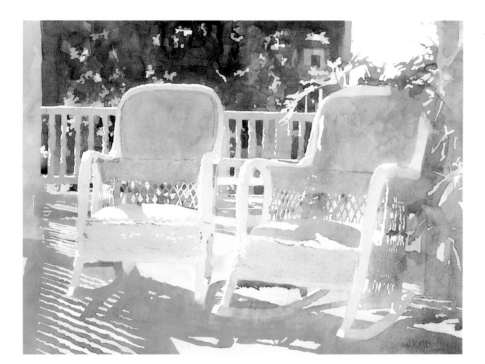

Judi Betts "I use many thin *layers* of glazing, often from three to twelve layers. The process of scrubbing out light areas is important to me. I use 3" x 5" cards and a sponge. I tear the cards, or cut negative shapes."

Rockin' Rhythm

22" x 30"
Judi Betts
Collection of Mrs. Jack Sanders

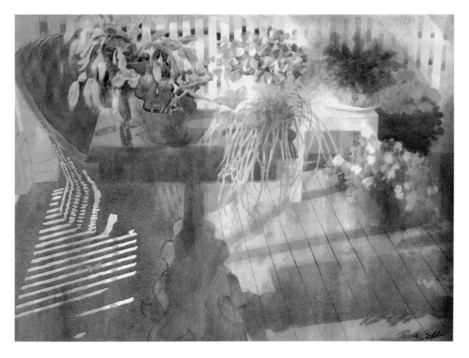

Ruth Cobb "I like the effects of smooth paper ... less absorption ... more reflected light. I plan ahead for whites, making use of transparency, gradation, dry brush and scrubbing out. I occasionally do use a masking agent."

"There are some painters who deal with the play of light as the most graceful thing that exists."
—ROBERT HENRI

Sun Stripes II

25½" x 35"
Ruth Cobb
Cobb uses Arches or Whatman hot-press paper.

Laundry on Monhegan

15" x 22"
Judi Wagner

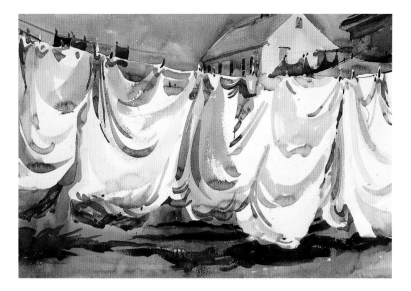

What better chance to display rhythmic accents than this series of paintings with the same theme—laundry? The laundry shapes dance from the line in the breeze and in the warmth of the solar dryer. The shapes repeat, displaying active, moving qualities. Try looking at the laundry as abstract shapes interlocking with the backgrounds and moving across the composition with an entertaining quality.

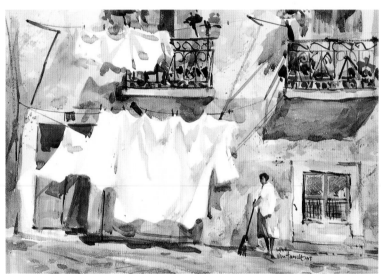

Portuguese Laundry

15" x 22"
Tony van Hasselt

Lunes, Portofino

22" x 30"
Jane Burnham
Jane Burnham uses 140-lb. Arches or Lanaquarelle cold-press papers and 240-3 Strathmore illustration board.

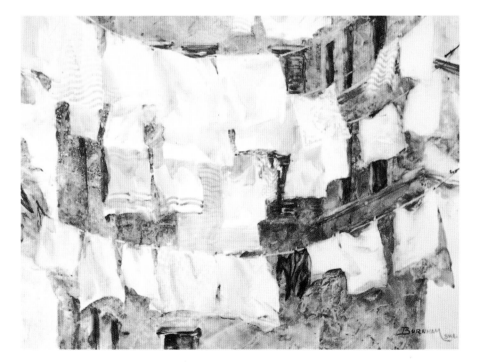

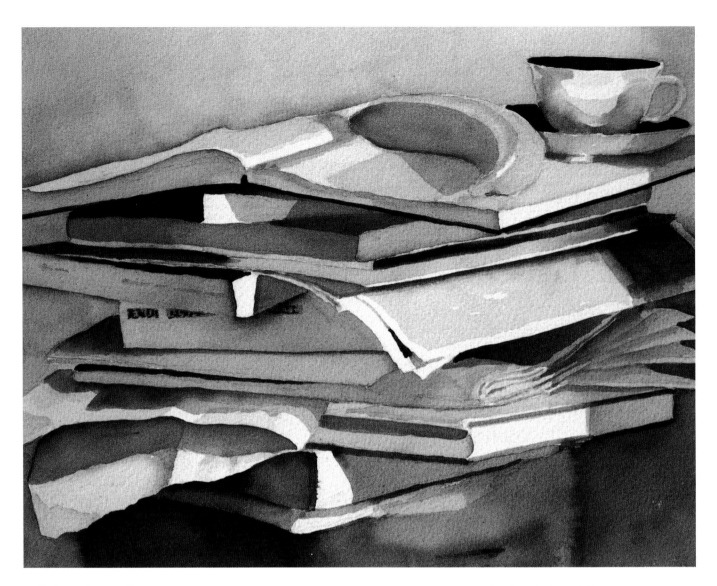

Aldryth Ockenga

Student's Breakfast

14" x 18"
Aldryth Ockenga
Ockenga prefers 300-lb. Arches as well as
Fabriano printmaking papers for wash
drawings.

"I like having the option of working very wet without the paper buckling or without having to stretch it. I also like the way the stroke takes on 300-lb. Arches paper. On the Fabriano printmaking paper, I like the blotting paper effect, especially when doing wash drawings of the figure. I can work over the first wash quickly and freshly. I also like the yellowed surface, since it creates a softer look."

Ockenga goes on to say that although she doesn't use any special effects, she would if she thought it would help with the basic idea and image. "I prefer to work in a very fresh way, leaving my whites without masking and repeating them rhythmically, using as few layers as possible."

Jane Burnham

"I use a series of glazes. First, I create a mixture of one part Liquitex Gel Medium diluted with two parts water. I then coat the surface of my paper evenly. When this sealing coat is dry and set, I apply a wash of two chosen colors to start. When this first wash is dry, I can lift out light values and white accent patterns where needed and add any additional colors."

Emergence

22" x 30"
Jane Burnham

"It is better to be nothing, than an echo of other painters. The wise man has said, when one follows another, one is always behind."

—COROT, FRANCE, 1856

George S. Labadie

"This painting was planned around a group of native women discussing village news. Although each figure would retain her personal character, all would be unified by arrangement of shapes, design patterns and sharp whites of tropical sunlight. Complexities were deliberate for interest but relieved by the light baobab tree trunk and dark background foliage."

Step 1

A dark-and-light sketch organizes the various shapes, determines the light source and direction, and builds a linkage of whites for contrast with dark shadow areas. The chickens are added to expand the white pattern into the ground and picture edges.

Step 2

Once the general organization is determined, a careful contour drawing is made. Specific costume designs and colors are left to be decided during the actual painting.

Step 3

Most compositional factors are now resolved so that shapes can be painted as they relate to each other in value, color and texture, to achieve continuity with variety. Brush work as such is kept to a minimum. As the shapes grow, fabric designs are detailed in the shadows, allowing the white of the paper to become the dominant and cohesive value element in the painting. The darkest darks are placed where they meet the whites.

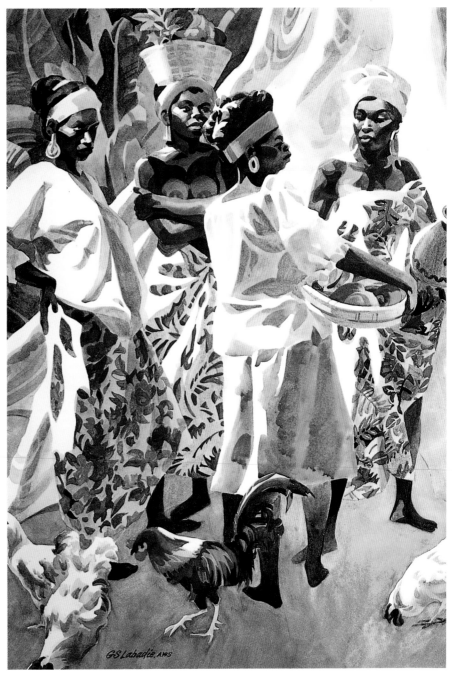

"Art, to my way of thinking, involves the sharing of an experience."

—WILLIAM F. REESE

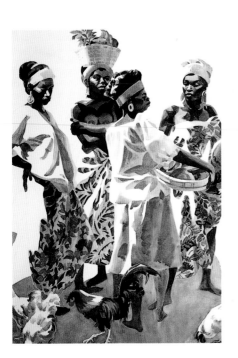

Step 4

Both the light and the dark shapes are executed in an almost geometric manner, thus lessening any conflict between shapes where detail is important. Light on the figures is very bright, almost harsh. There are no shadows on the ground since cast shadows in the area of the feet and the chickens would create an impossible confusion. Surfaces can be either highly reflective or totally absorbent. It is the artist's choice.

Step 5

In final stage of the painting, I develop some minimal light form in the baobab tree trunk and close-valued dark greens in the background banana trees. The vitality of the painting is achieved by the whites of the paper dancing through the entire scene.

Dahomey News Conference

35" x 24"
George S. Labadie

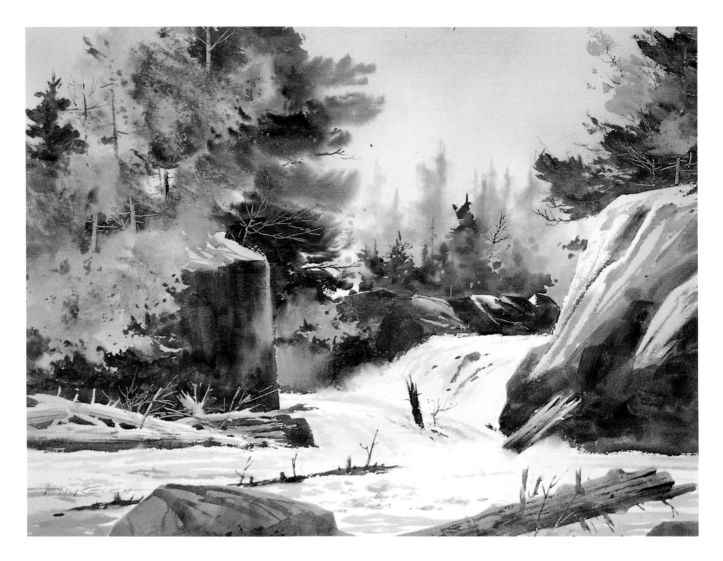

Attracting the Eye With Value Contrasts

Whites take on added importance when they are placed next to strong, dark shapes. The eye is *forced* to look at this value contrast. It is our job to make sure that this value contrast is placed well, at the center of interest.

Tony Couch "I always leave white paper; I'm certain to make it a nice-looking shape, and I usually put it at or near the center of interest with a good dark right next to it. That will make you look there."

Split Falls

22" x 30"
Tony Couch
Couch uses 140-lb. Arches cold-press paper.

"The study of art is the study of the relative value of things."

—ROBERT HENRI, *THE ART SPIRIT*

Carl J. Dalio "I consider my painting to be direct and spontaneous, after planning for composition and value contrasts. I leave white paper for the strongest whites, without special effects of salt or whatever. That value of the white paper achieves luminous effects, and those white shapes gain the most energy in a composition."

Near Bear Lake, Rocky Mountain National Park

10" x 14"
Carl J. Dalio
Collection of Phillippe and Cynthia Dunoyer
Dalio mostly uses Arches 140- and 300-lb. cold-press papers.

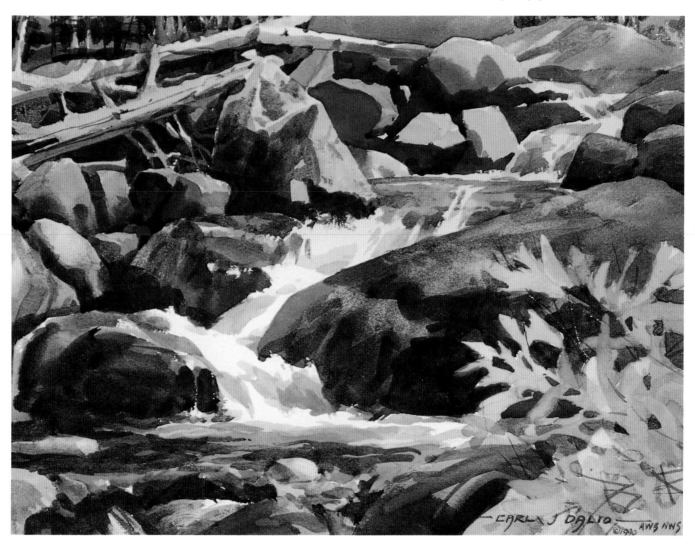

Strengthening Whites by Contrast With Darks

In a painting with a dominance of dark values, the whites take on added strength. Interior subjects or night scenes, for example, can have various light sources that add intrigue and variety to composition possibilities.

Cibola is an unusual landscape/still life that focuses strong light patterns over a still life of horsemen, sand and a desert plant. One stops to wonder about the out-of-scale size relationships. The strong, dark values create the contrast that sets up the spotlight effect on the subject. The artist sometimes resorts to Winsor & Newton liquid mask but also uses tape that is carefully cut with a craft knife while on the paper surface.

Cibola

18" x 28"
Warren Taylor
Collection of Mari and Robert Workman.
Taylor uses Arches papers exclusively.

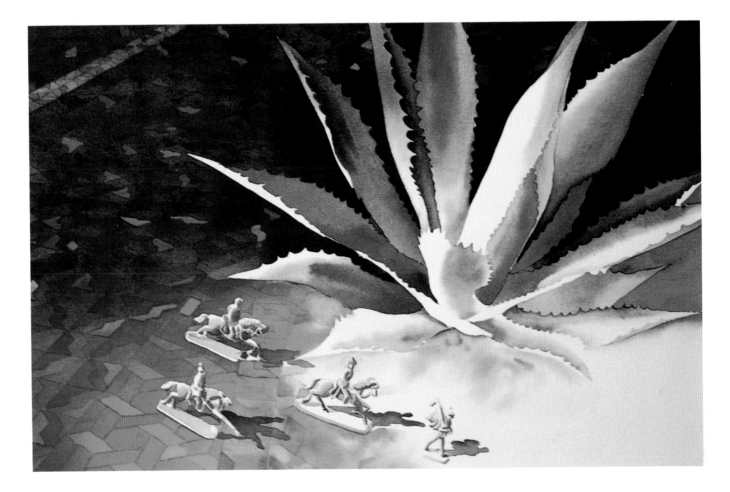

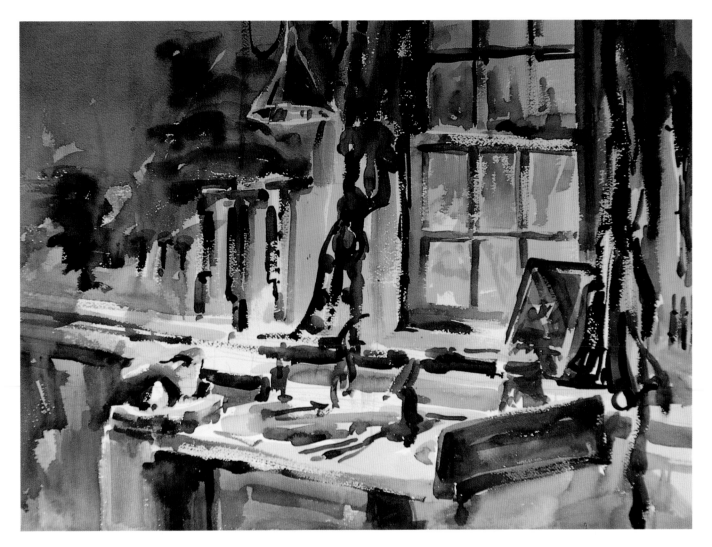

In *The Tinsmith's Shop*, the window and the overhead lamp are the light sources against which the tinsmith's bench and various tools are displayed. The gradating darks along the painting's edge set up the contrast for the lights and whites, which tell the story in this painting.

The Tinsmith's Shop
22" x 30"
Judi Wagner

"How much light there is out of doors. Look out of the window and note how light the darkest spots in the landscape are in comparison with the sash of the window."

—WILLIAM MERRITT CHASE

CHAPTER THREE
Intensify Color and Light

Golden Fall

15" x 22"
Tony van Hasselt

"More and more I believe it's not how well one paints that makes the difference, but how well one sees." —WILLIAM F. REESE

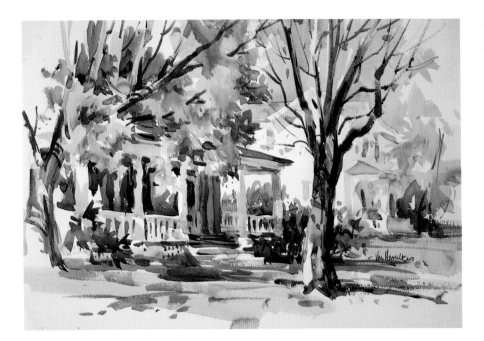

Golden Fall lets us enjoy the strong light source that illuminates this scene and directs the eye. The simply shaped and untouched paper surface in the background tells the story of the next house, but does not steal the spotlight from the tree displayed against it.

Much of the paper remains untouched in *The Nautical Antiques*, expressing the building's sun-washed surface and the heaps of nautical equipment. The shadows link the items together against the dominant building color and shape. By intensifying the color with the creative use of lights and white paper, the subject is given added importance and punch.

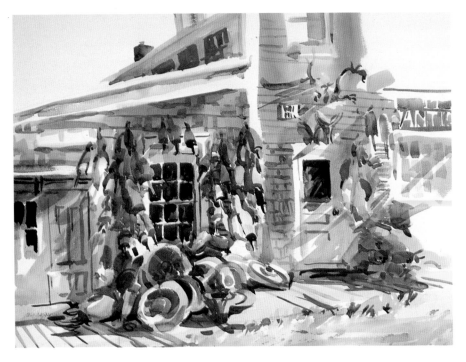

The Nautical Antiques

22" x 30"
Judi Wagner

58

In the first phase of *Stonington* (at right), George Delaney creates a strong light pattern with large, broad variations of gray washes that point fingers at the light with interlocking edge excitement. The finished version (below) shows the additional glazes and details superimposed *on top of* the all-important first wash. According to Delaney, "White paper is the light that comes through the transparent color. It's the difference between looking at a photograph and at a transparency."

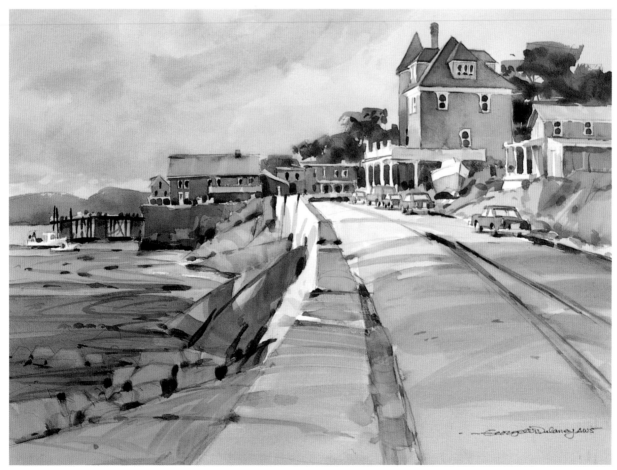

Dale Laitinen

"My goal as a painter is to eliminate white where it is not needed. A stone sculptor does the same when cutting away unnecessary stone to reveal what the eye and spirit know is already there. It is essential for me to engage in a conversation with my materials and idea, with some give-and-take in the process. Whenever I have a totally preconceived notion, I ultimately fail. This is not to say I don't prepare. Through observing, dreaming and sketching, I let my mind and spirit form opinions about the direction I need to take, but to a certain extent, I am willing to be led by what happens.

"This becomes very important when cutting away the light on the paper. I need to be alert to the possibilities as they present themselves. I think about each layer of color as a transparent lamination. With each lamination, I block out more and more white until only the essential lights are left. This is what makes these lights more luminous. *Lake Near the Crest* has a wide range of translucent passages, moving from the almost-white snow patterns to dark darks. In painting, everything is relative. It is what you put next to it that counts."

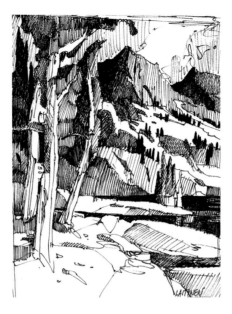

A preliminary value sketch helps me visualize whites and lights. The snowfields create an interesting design against the dark mountain face. I mass in the dark lake as contrast to the light in the shoreline rocks. The lights in the trees along with lights in the top and bottom of the format unify the composition.

Step 1

After the underpainting of yellow ochre, French ultramarine blue, Winsor green and burnt sienna is completely dry, I paint in the dark, cool sky, so the clouds become warm and luminous with the first washes shining through. The foreground shapes are defined with French ultramarine blue and burnt sienna; I carefully avoid the tree trunks so they would be unaffected by underlying color. The warm shoreline area represents underwater rocks to be glazed over later.

Step 2

After the underlying washes are dry, I brush in middle values on the mountain range with a gray-purple mixture of French ultramarine blue and alizarin crimson. While this wash is still wet, I add cadmium red and yellow ochre for warmth, and cerulean blue for richness in cooler areas to create luminosity. I am careful to paint around my lights, which produces a striking dark-light pattern with the almost-white snow.

Step 3

At this stage, my strategy is to eliminate some lights so the remaining light will appear stronger. I paint a purple-gray mixture in the mountain shadows and add cerulean blue for aerial atmosphere and opacity. The heavier shadow passages and almost-black distant tree line make the lighter rock face and snow pattern even more luminous. I add the foreground tree trunks with warm and cool colors to create the warm light on them.

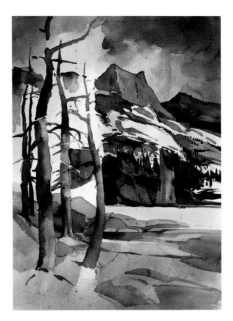

Lake Near the Crest

30" x 22"
Dale Laitinen
Laitinen uses Arches rough in various weights and sizes.

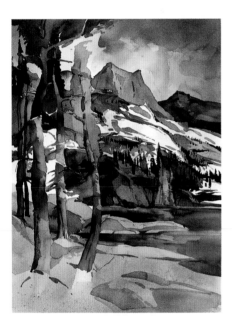

Step 4

Using cadmium yellow, burnt sienna, French ultramarine blue and some Winsor green, I mingle these colors over the warm lake rocks. These cool darks establish a strong edge to my foreground shoreline. I block in the foliage by filling in the blank white space around the trees. In the trunks I add shadows and detail for solidity and to enhance the glow of warm light on their surfaces. Some whites are saved for further background development.

Step 5

I fill in the white areas behind the trees, integrating the negative and positive shapes with the background, and tying it to the rest of the painting. Finally, I add detail such as bark texture and foliage.

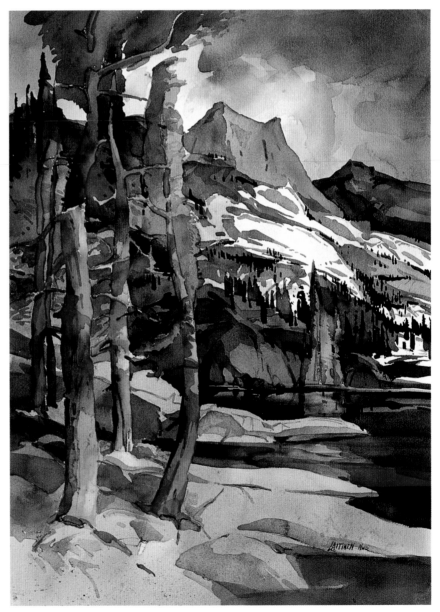

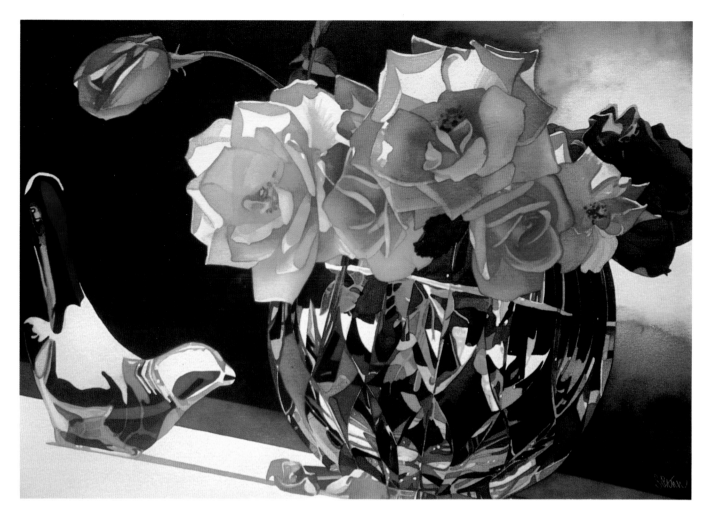

Using Washes and Glazes for Brilliant Transparency

When light shimmers through glass, brilliant transparency comes to mind, and the glazes that depict this state astound us. Taking the idea of transparency literally, the examples on this and the following pages directly present and create new awareness of this thrilling use of the watercolor medium.

In *Gypsy Souls With Wings of Gold*, one looks at the wide range of values—the white table and the light source as well as the translucent light seen through rose petals and facets of cut glass. The dark background works its own magic, setting up, balancing, contrasting and holding the composition together. Spann exclaims, "I plan for the whites and then I leave those suckers alone!"

Gypsy Souls With Wings of Gold

25½" x 31"
Susanna Spann
Spann uses 300-lb. Arches
cold-press paper.

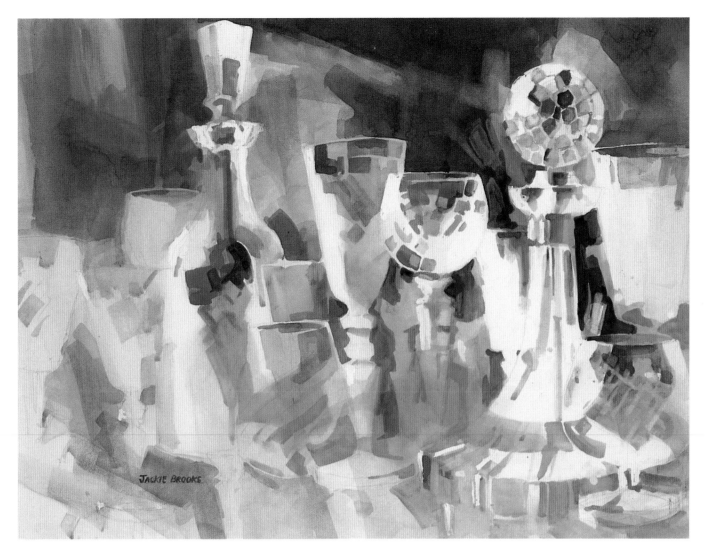

Crystal Series #9

30" x 40"
Jackie Brooks
Collection of Marc and Cathy Vaucher

Jackie Brooks offers another look at a glass composition. In *Crystal Series #9*, lost and found edges are achieved by soft and hard washes. The dark values are effective in contrast with sensitive washes, and the delicacy is set off by the bold, cohesive background.

When the brilliant transparency within washes and glazes is used in portraiture, the use of the light source is paramount for a strong statement. Both paintings pictured here display artful uses of light source and glazes. George Delaney, talking about *Nascimento*, states, "Related white shapes lead the viewer to the details of this very interesting face."

Robin

22" x 30"
George S. Labadie

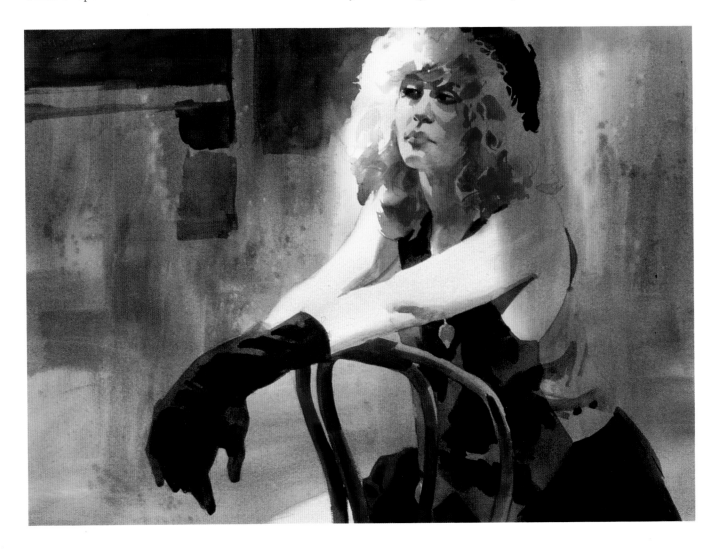

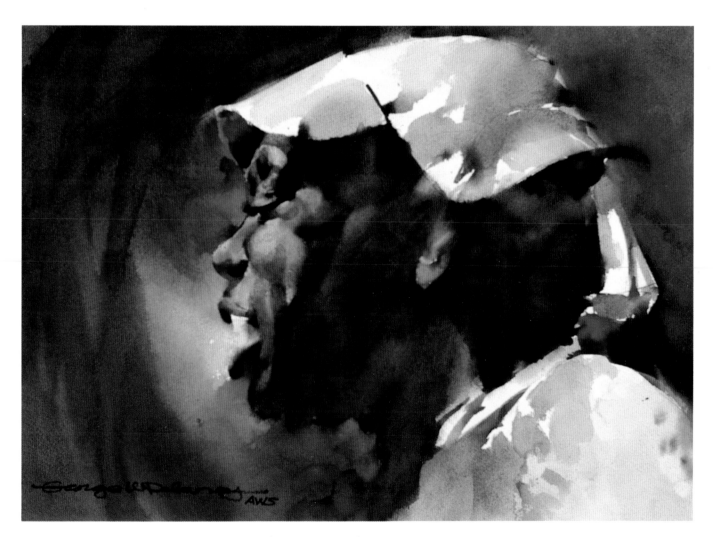

Nascimento

15" x 21"
George W. Delaney

"There is a special joy in witnessing

a championship performance—in

tennis, in politics, or in painting."

—THOMAS S. BUECHNER

George W. Delaney

George Delaney's step-by-step demonstration is an excellent example of brilliant transparency achieved with direct washes and glazes. Delaney points out that *New Castle* stresses the use of white shapes and how to judge them in the first phase of the painting.

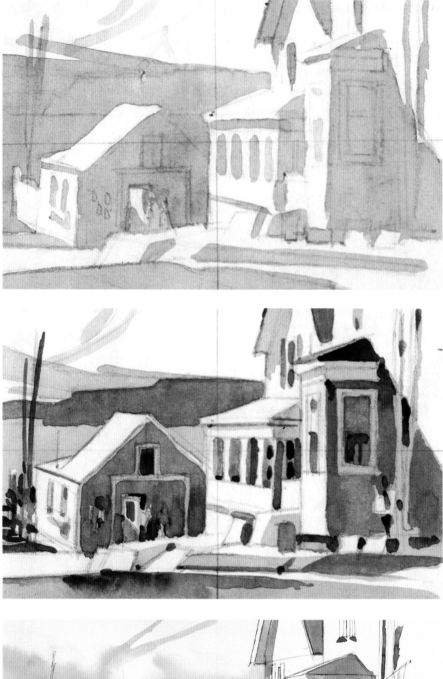

Step 1

I start with a small midtone sketch that allows me to clearly see, judge and balance the white shapes.

Step 2

A pattern of darker values is added to this small preliminary sketch to create a three-note chord consisting of a light value, a midtone and a darker value.

Step 3

After drawing in the subject on the actual watercolor paper, I apply a midtone mixture made up of shadow and local color suggestions. This is the color midtone of the shadow areas.

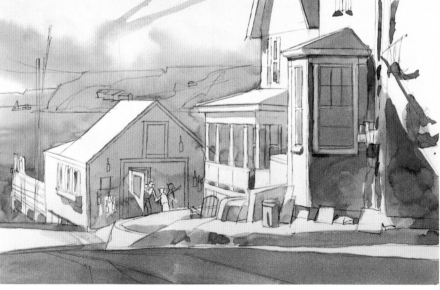

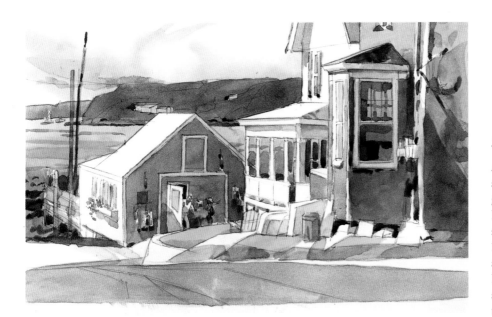

Step 4

After these midtones are completely dry, I add the local color midtone of the green grass, the brown house and the distant head-lands. The local color is painted over the sunlit, white areas as well as shadow areas. Note, for example, the immediate sunlit look along the right edge—how bright the color looks when applied over the white, sunlit areas, compared to when it is glazed over the cooler, darker shadow color.

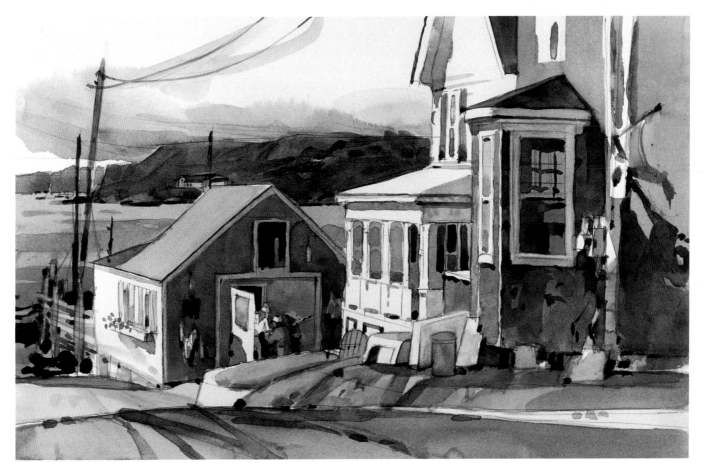

New Castle

12½" x 19½"
George W. Delaney

Step 5

Finally, I add some dark accents and modify some of the white areas with very pale warm and cool tones.

Creating the Illusion of Light With Reflections

In *Early Morning*, the low early-morning sun spotlights boats against the deep shadowy background. This painting allows the study of white paper and lights being reflected by the boats. The sunlight in the reflective water surface convinces the viewer about the effect of real paper transparency.

Cedar Key Dock and *Shrimper at Rest* are other examples of reflections at work to create the illusion of light and color.

Early Morning

22" x 30"
George W. Delaney

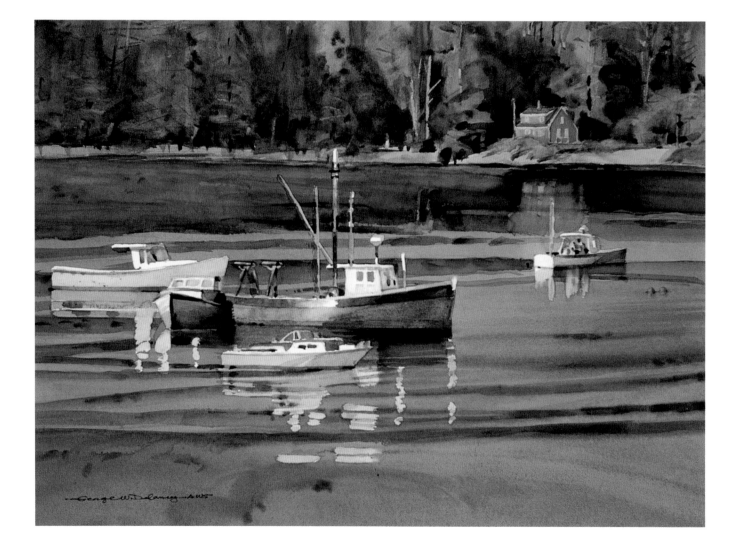

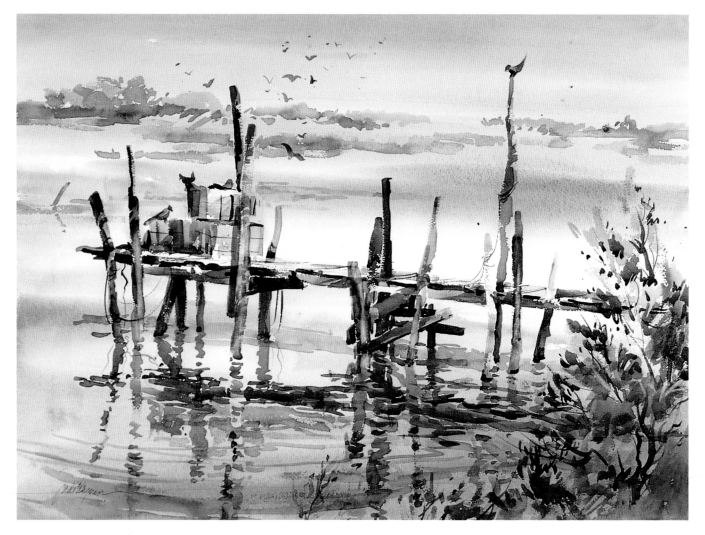

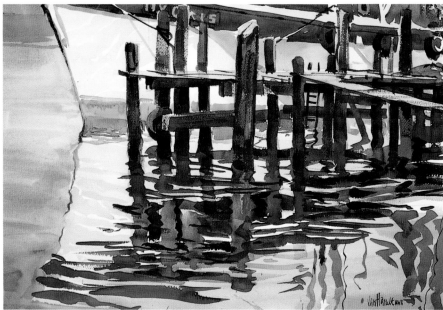

Cedar Key Dock

22" x 30"
Judi Wagner

Shrimper at Rest

15" x 22"
Tony van Hasselt

Marilyn Simandle

Marilyn Simandle's paintings on these two pages clearly show how the artist used the white of the paper to create the illusion of reflected light. Marilyn says, "The artist should look at the white paper in the same way a sculptor sees the shape inside the piece of marble. The sculptor chisels the unnecessary pieces away, just as the painter paints the negative shapes around the whites or lights. If a painter does not understand negative shapes, he or she will get into trouble. All good painting is

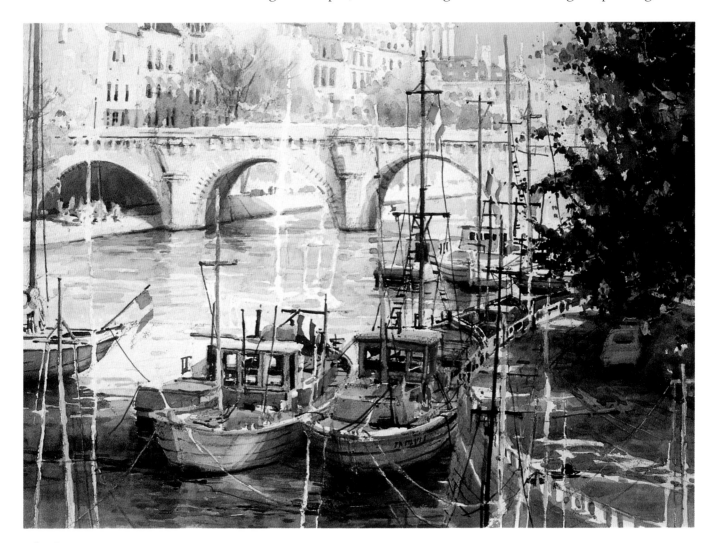

The Seine

22" x 30"
Marilyn Simandle
Simandle uses 140- or 300-lb. Arches or Winsor & Newton papers.

In *The Seine*, the complicated architectural details are treated simply in a high-key mass of light values repeated in the reflections. This light area is accented and framed by the strength of the foreground shadow area, which is kept alive by entertaining shapes and a sun-dappled treatment. The dark arch of the bridge is an important balancing aspect of this composition. The reflection of the bridge arches and boats call our attention to the water and link the design together.

good composition. Good composition is also simple shapes. Connecting the darks and whites into a single mass makes a more pleasing painting.

"I always start a painting with the largest shape; the last strokes are the dark details. I never 'fall in love' with one area of the painting, but always consider the whole. That's why I stand while painting, so I can back up about ten feet and view the whole composition and harmony. A successful painting must have harmony along with contrasts. I usually use the full range of values to create drama. Of course, in watercolor, you can only get darker, not lighter."

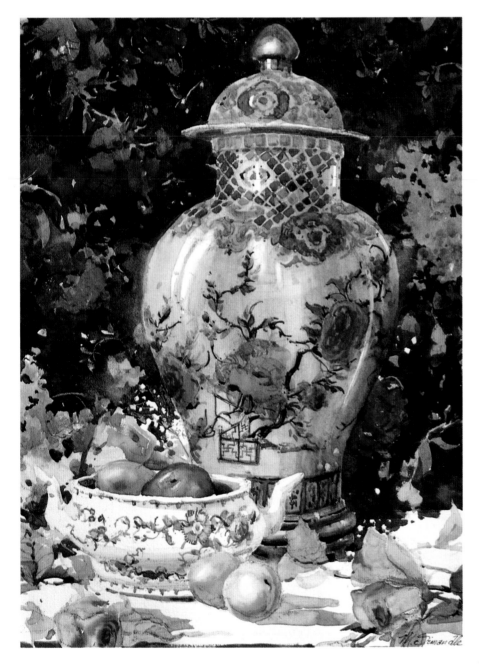

Victorian Vase

24" x 18"
Marilyn Simandle
Because light values are concentrated in the foreground of *Victorian Vase*, the vase with its highly reflective surface moves visually into and becomes part of the darker background. The modulation of floral shapes in close value harmony sets a fine stage for the smooth, rounded texture on the vase. Another light reflection appears on the fruit surfaces and flowered bowl. The shadow pattern links the elements in the foreground composition while restating the light's direction.

Separating Primary Colors With White

When white space is used to separate primary colors, the colors stay strong and the whites appear to take on an importance at the same level as the primaries. Similarly, when primary colors and whites are separated by black outlines as in the paintings by Piet Mondrian, they stay strong and vibrant. In both cases, there is a need to balance the colors as well as the white spaces.

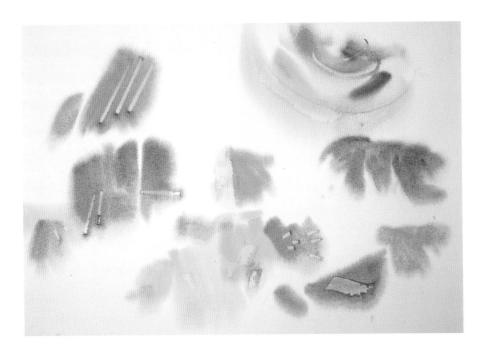

Step 1

I thoroughly wet a sheet of 140-lb. Arches cold-press paper on both sides. Having a subject in mind, but not hindered by pre-drawn outlines, I apply primary color 'spots' on the wet sheet, making sure that each color is balanced. Colors do not touch each other; all are surrounded by white paper. Next, I add some analogous color variety in the sun and foreground areas, as well as some calligraphic scrapes and texturing.

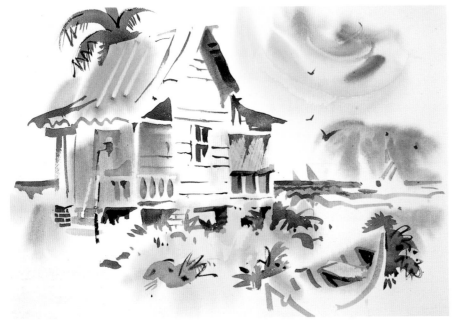

Step 2

After the paper is dry, a minimum of calligraphic detail is added using symbolic brush work and shapes suggested by shadows and foliage. Making these marks, I avoid enclosing any area, so the white space flows unimpeded through the composition.

Primarily Calligraphic

15" x 22"
Tony van Hasselt

Dan Burt's *Callejon Numero Uno* exemplifies this thought. Burt states: "I like to have the highest chroma color with its opposite in and around the focal point. I also like to have a saved white with the darkest dark next to it in that area."

Callejon Numero Uno

30" x 22"
Dan Burt

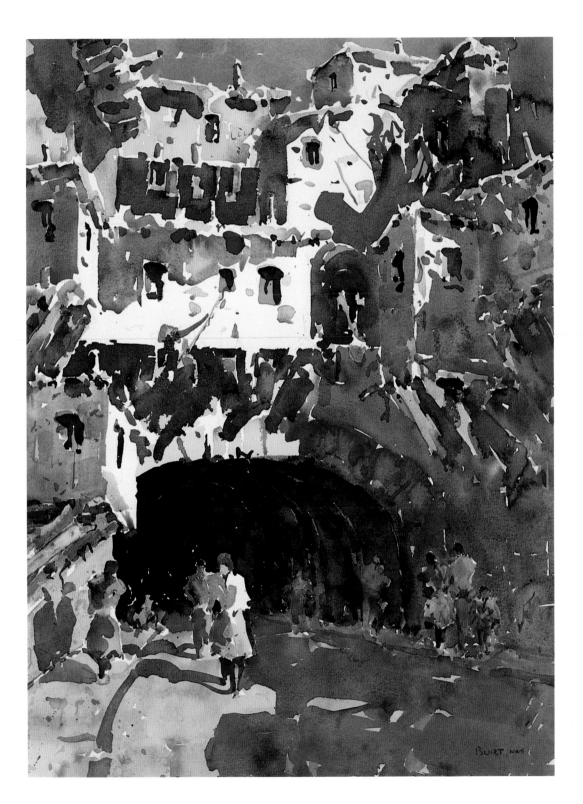

Juxtaposing Colors and Whites

An exciting checkerboard effect is created by the contrasting placement of colors against white paper, darks against lights, warm colors against cool ones and textured areas against simple ones.

Janet B. Walsh "I wanted this painting to be white on white, with the flowers counterbalancing the darks of the fruit and a suggestion of lace."

"One becomes in time so sensitive to color harmony that the instant one puts on a false spot of color, it hurts, like the wrong note in music."

—WILLIAM MERRITT CHASE

Pitcher and Bowl

30" x 22"
Janet B. Walsh
Private collection

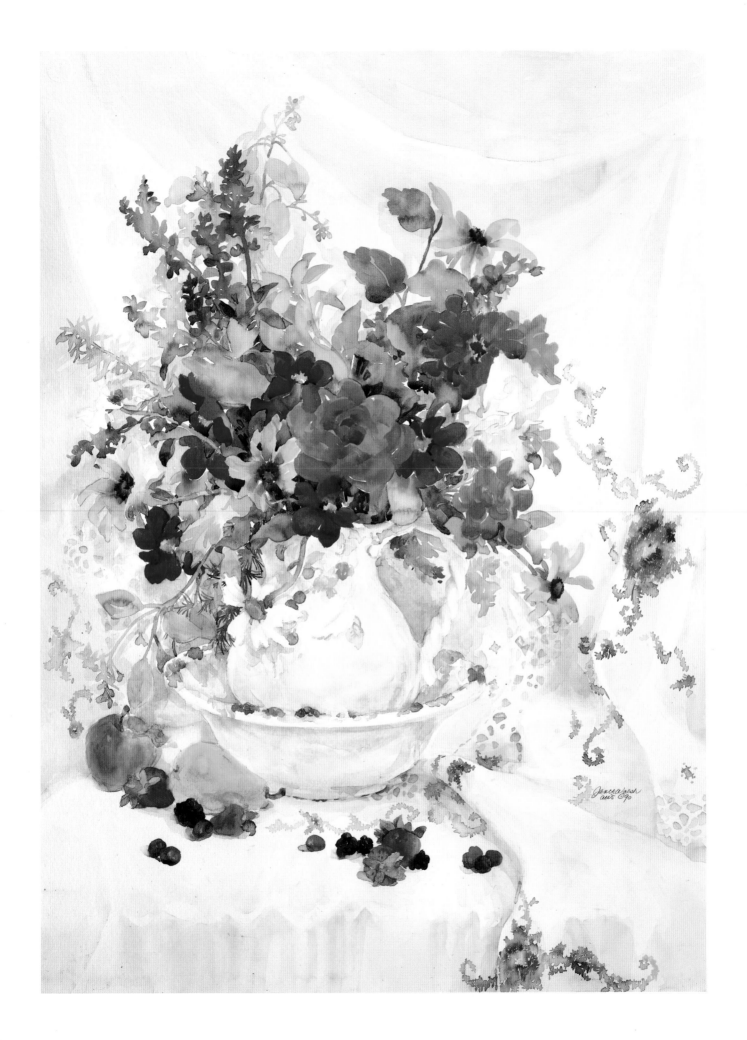

Ruth Cobb

The linking together of the whites in *Laces and Fruit* balances and moves the eye through the composition, which is punctuated and framed by the warmly colored background. Cobb plans ahead for the whites, and uses masking agents, transparency, gradation, dry brush and scrubbing out.

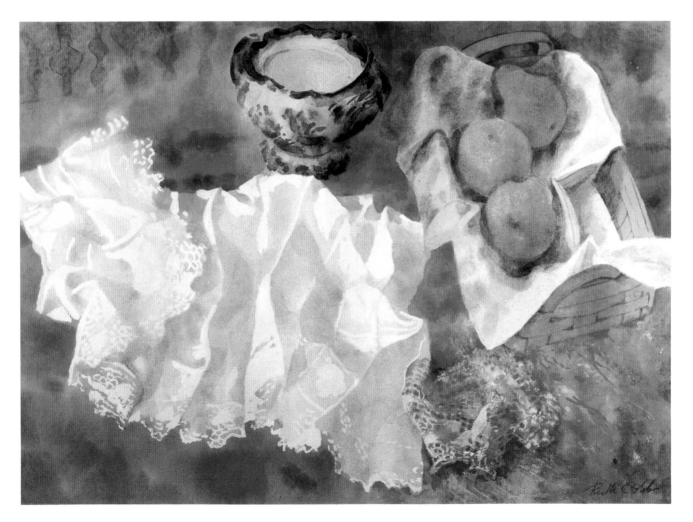

Laces and Fruit

21½" x 29¾"
Ruth Cobb

Serge Hollerbach

In *White Slacks* and *Cooperstown in Winter,* the simplicity of style emphasizes the importance of white paper. These are two excellent examples of juxtaposed colors and whites checkerboarding in a simple style with few values. According to Hollerbach, "I use white paper as a 'color' and as neutral space that surrounds figures."

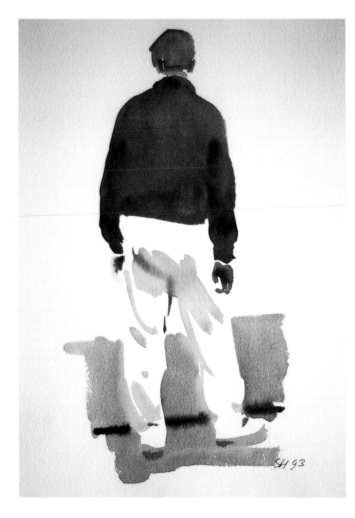

White Slacks

10" x 7"
Serge Hollerbach

Cooperstown in Winter

9" x 6"
Serge Hollerbach

In Mary DeLoyht-Arendt's demonstration painting of *The Willow Chair*, the whites of the surrounding areas emphasize the texture and color of the chair and flowers. These whites create an important quiet space in contrast with the busy subject matter.

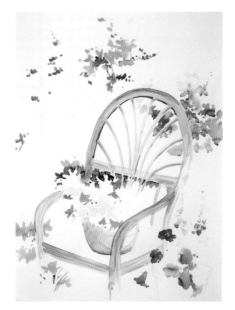

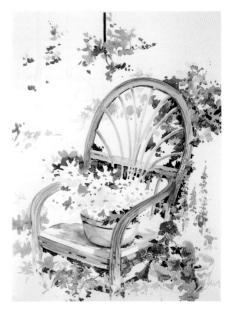

Step 1

I begin with a small compositional sketch to determine the size of the chair relative to the paper size, the importance of the wrought iron, and the amount of white to be left.

Step 2

On the actual paper, I just draw in the chair, wrought iron and flower pots. Only the iron is drawn with precision; the rest is roughed in so that the painting process can indicate to me what the needs are. I wash in the chair shape and a few colors for flowers here and there, adding random shadows where the white flowers will be.

Step 3

To develop the center of interest, I define the white flowers and the chair by painting the negative shapes of greens and flowers. Next I establish the shadows on the cushion and bowl to show the light source, and I add the wrought iron vertical.

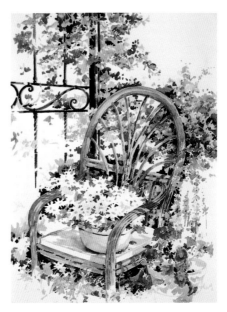

Step 4

I begin to fill in the colors, like putting together puzzle pieces, varying the shapes and values.

Step 5

I work in different areas, skipping around so that the whole painting develops at one time. Holding a mat up to the painting shows me there is still too much white and that the wrought iron stands out too much. More color is placed behind it, and some warm rust color is added to the iron to avoid harshness.

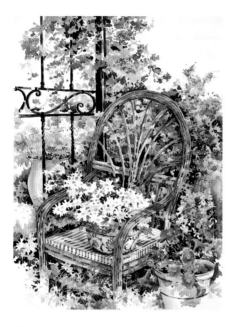

Step 6

I add the stripes of the cushion and the design on the pots. The strong structure of the gate and chair contrasts against the more painterly flowers and leaves, a contrast of loose as well as controlled areas.

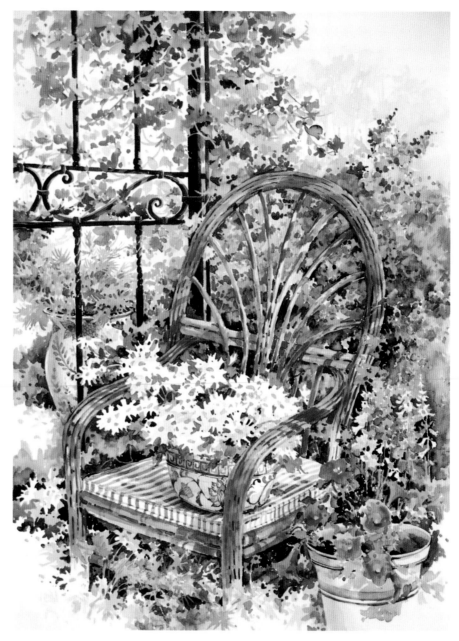

Step 7

In this final phase, I add more color and a few very light washes to suggest trees in the distance. The white, a welcome relief from the activity going on elsewhere, is neither dominant nor unimportant. It isn't the center of interest, but it does add sparkle and a welcome calmness.

The Willow Chair

30" x 22"
Mary DeLoyht-Arendt
DeLoyht-Arendt uses mostly Lanaquarelle paper, but also the back side of Alpha Mat Bainbridge illustration board for oversized compositions.

Add Drama and Mood With Whites

In both *Ejido* and *Atlas Maru II*, we see the drama of subject matter being controlled and heightened by the use of the whites and the placement of those whites at the focal-point areas. Also, the strong, contrasting darks—deep shadows caused by light sources and backgrounds—come together to create very moody compositions.

"Don't hesitate to exaggerate color and light. Don't worry about telling lies. The most tiresome people— and pictures—are the stupidly truthful ones. I really think that I prefer a little devilry."
—WILLIAM MERRITT CHASE

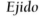

Ejido
24" x 35"
Warren Taylor

Atlas Maru II

21" x 28"
Donald J. Phillips

Nothing focuses in on a strong, moody idea than oversized form. In *Marching to the Miami Beat*, the lights of the flowers dominate, with punch supplied by the strong background. The small amount of reflectivity in the vase varies the surface quality. The exotic orchids exude a strong moody aura, while the transparency of the petals and the rhythm of the stems all heighten the sense of moodiness in this piece.

Susanna Spann uses Arches 300-lb. paper because "it is predictable, strong, has tooth and portability."

Early stage of *Marching to the Miami Beat*

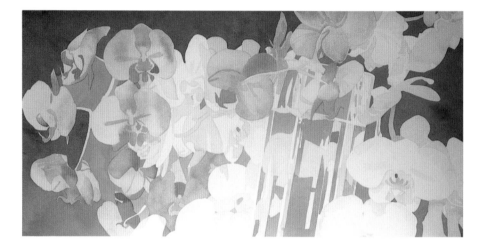

Detail of *Marching to the Miami Beat*

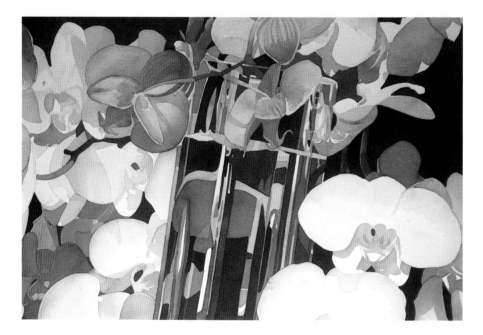

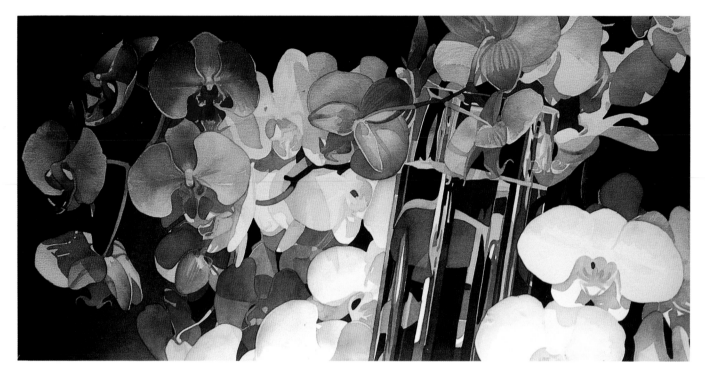

Marching to the Miami Beat

40" x 60"
Susanna Spann

Varying Shape Size for Imaginative Effect

In *Pieces of Light II*, the artful use of darks and overlapping lights is an excellent example of the large shapes setting up the mood for the extensive variation in white shapes, which display balance and thrust.

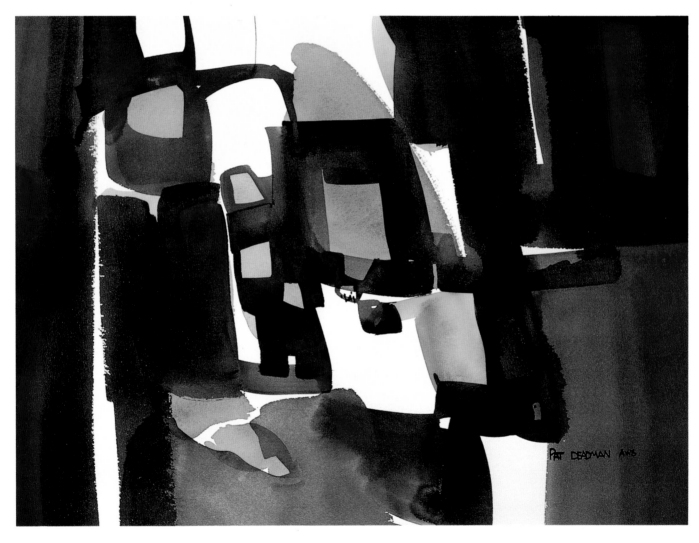

"A fine painting is not just the subject, not just the article or the image on the paper. I think it is the feeling conveyed of form, bulk, space, dimensionality and sensitivity—the mood of the picture—that is most important."

—OGDEN PLEISSNER

Pieces of Light II

22" x 30"
Pat Deadman

In *New Beginnings*, Jane Burnham used an explosive piece of subject matter—a small dark splashing onto the light (white) background. Each area has been thought out regarding its effect on the other. The variety of edge and transparent washes adds to the mood.

"If inspired performance has a hallmark, it is spontaneity."

—THOMAS S. BUECHNER

New Beginnings

24" x 39"
Jane Burnham

Margaret M. Martin

"*A Basket Gathering* was arranged in my studio using fresh, white tulips and lilacs from my garden, a basket, and jewel-colored fabric from my collection. I was excited by the drama of lights and darks in this arrangement and aimed for a bold, crisp, sparkling statement. I tried not to get too involved in little details. A painting is successful if the big areas are handled directly and solidly."

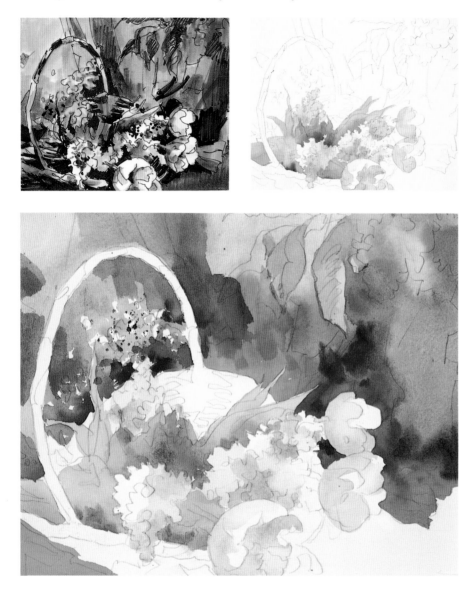

Step 1

My value sketch focuses on mass, center of interest and structure. The relationship of dark-and-light pattern—not color—is the consideration. The lightest lights on the tulips and lilacs will be saved white paper and will be my intended focus.

Step 2

With a decent drawing, I have the confidence needed to be bold. I wash off the sizing from the 140-lb. Arches cold-press paper, and when it's dry, I attack the light shadow shapes of the white flowers, aiming for fresh, luminous color. White shadows can be any reflected color as long as the values are believable. Delicate applications of French ultramarine blue, Thalo blue, cobalt violet, rose madder and Winsor yellow merge, letting the natural action of water and pigment take charge. I paint the lightest value mass of green foliage, warm and cool, using Thalo green, new gamboge, burnt sienna, Thalo blue and a complement of rose madder in close value harmonies, blended on dry paper.

Step 3

I lay in the large background area linking the subject and foreground to create a wholeness. My guides are the fabric for color and the sketch for value. Using a flat, 1½-inch brush, I lay in a wash variation of cobalt violet, Thalo blue, Thalo green and permanent rose. Working on dry paper, I cut around the white tulip shapes and leave a few white spots behind the basket to suggest white baby's breath. While this large wash is still wet, I charge it with darker values to suggest direction and space. I establish the turquoise napkin, lower left, with Thalo blue, Thalo green and cerulean blue.

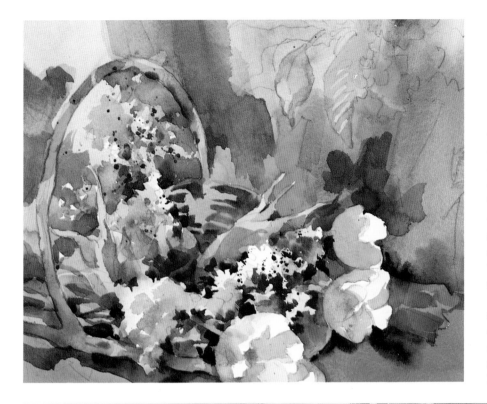

Step 4

I indicate the foreground cloth with ultra-marine blue, and, while it's wet, add more pigment under the basket. Burnt sienna and Winsor red are applied to the basket, and, when dry, ultramarine blue, burnt umber and cobalt violet are used in the shadow areas. A very dark application of burnt umber and ultramarine blue suggests wicker and shadows under the flowers.

Middle and dark greens are applied to stems and leaf edges, and a darker shadow color is glazed over sections of the white flowers to add more dimension. A few dark spatters are added on the lilacs to suggest a lacy character.

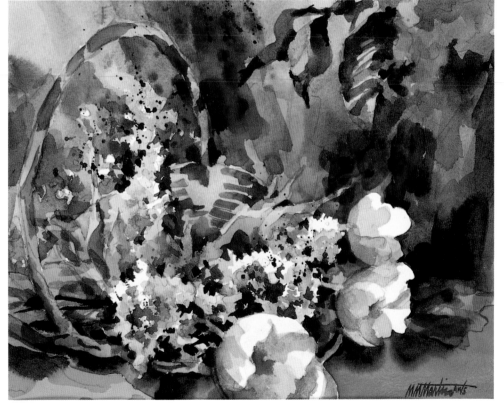

A Basket Gathering

19½" x 24½"
Margaret M. Martin
Private collection
Martin uses 140- and 300-lb. Arches cold-press paper.

Step 5

In finishing a painting, I look at the big areas, light-and-dark value connections, and warm versus cool color relationships. Some background adjustments are made, and darker tones are placed closer to the white tulips to make them sparkle. The leaves in the upper right get some darker definition, and the lilac shadows are strengthened. The turquoise napkin is given an additional midvalue shadow.

Creating a Stark or Light-Filled Mood

The lights and whites combine with the happy sense of musical activity, creating the desired feeling of levity in *Appalachian Suite*.

Appalachian Suite

25" x 39"
George S. Labadie

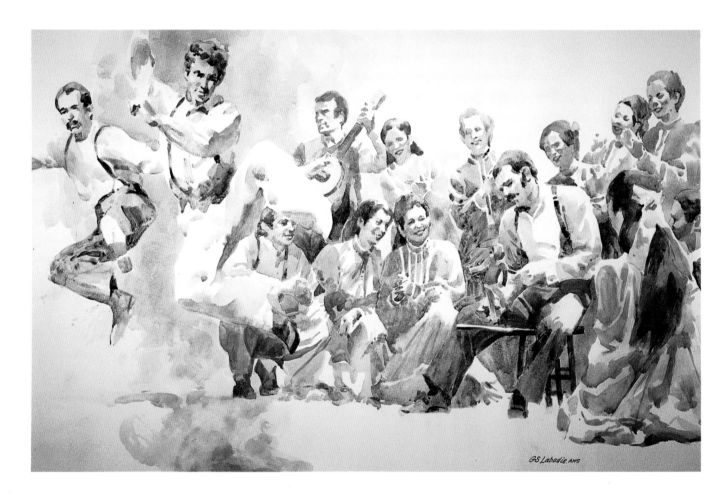

"An artist is known as much by what he will not permit as by what he includes in his painting."

—FRANK O'HARA ABOUT MOTHERWELL

French People

9" x 12"
Serge Hollerbach

French People has a well-designed and well-integrated pattern of white paper and subject matter that produces character and cleverness. White paper is of paramount importance in creating the mood in this work. Simplicity and a limited touch work to the artist's advantage.

Tony Couch

"One of the advantages of transparent watercolor over other mediums is its fresher, sparkling spontaneity. Nothing promotes this mood of spontaneity more than the contrast between the painting's dark and midvalue washes and a bright, well-placed white shape."

Step 1

I begin my planning with a value sketch. Next, I sketch the subject on a sheet of 140-lb. cold-press Arches paper. I wash in a nice variety of light values on the side of the building facing the viewer, since it is not in direct sunlight. I do this modeling first, so I know how dark to get with the midvalues. I leave the sunlit side as untouched white paper.

Step 2

I add the large sky wash, cutting around the building and small, white chimney shapes. I add other colors and strengthen values in the sky. While this area is still wet, I add a yellow-green mixture for the soft-edged trees in the distance.

Step 3

I surround the light adobe shape with fairly dark midvalues and place the darkest ones in the areas touching it, like the roof, trees and adjacent weeds. I am careful to make the midvalues darker than the light washes on the wall painted in Step 1. Now, by contrast, that area *appears* white, even though there are some light values washed into it.

Step 4

In this final step, I simply add enough detail to make the shapes understandable and interesting. I add a few dark accents, such as the figures and the doorway at the center of interest. All parts of the building facing the direct sunlight are left as clean, untouched white shapes.

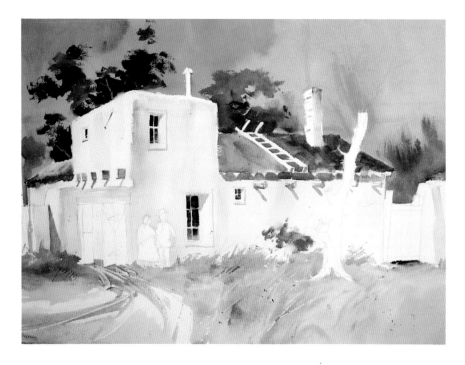

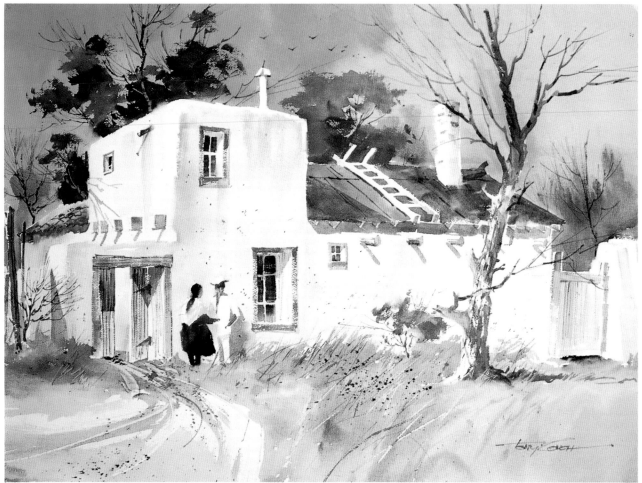

Adobe

22" x 30"
Tony Couch

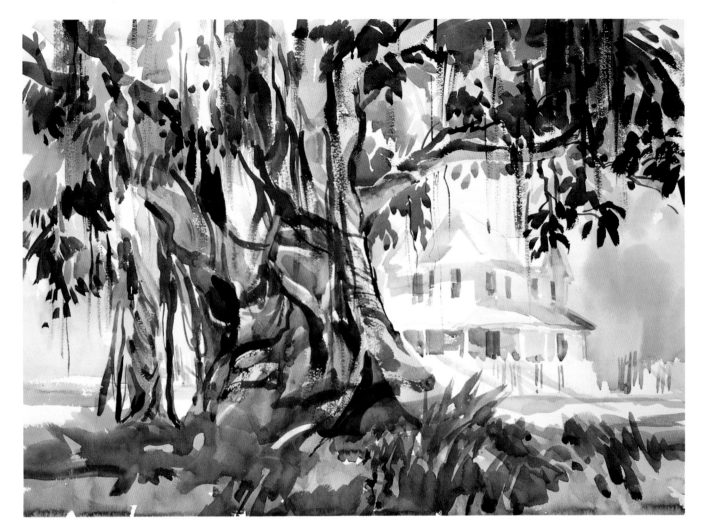

Using Edges for Backlit Mystery

The prospect of looking at a subject with the light from the back has the possibility of changing the entire mood of the painting. In *The Ficus Tree*, the backlighting places the viewer in the tree's shade, looking out to the light. By keeping the architectural structure understated, the pale values in the distance increase the dark contrast of the tree mass. This contrast sets up the hot, sunlit area and lets the texture and especially the edges of the tree foliage stay close, surrounding the viewer.

The Ficus Tree
22" x 30"
Judi Wagner

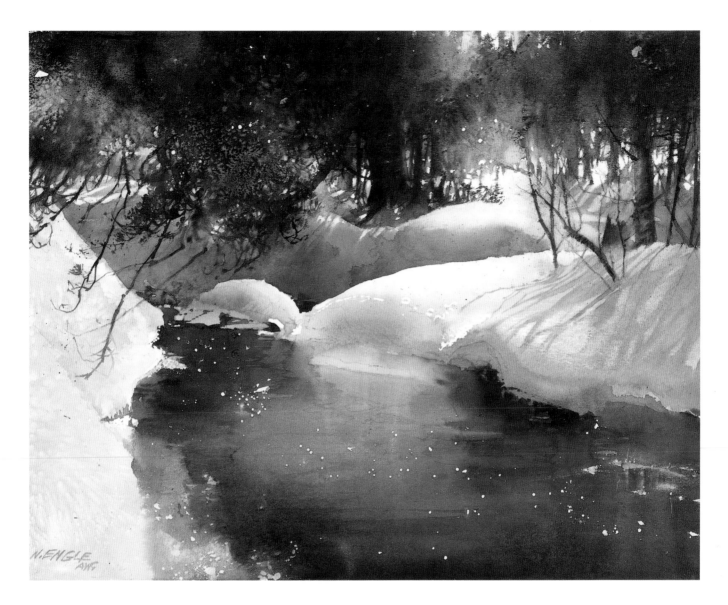

In *Winter Brook Series II* by Nita Engle, the backlight shines through the trees, reflects on the snow, sparkles on the brook's surface, sneaks through branches and diffuses at the light source, eating away the branches and tree trunks. The shadows support the light source and describe the snow contours. With the addition of light sparkles on the open, as opposed to iced-over, stream surface, more opportunity for sparkles abound.

Winter Brook Series II

22" x 30"
Nita Engle

"Into every life a little rain must

fall—why not take up watercolor?"

—JOHN PIKE

CHAPTER FIVE

Explore the Repertoire of Surfaces

Exploring the numerous approaches to using white effectively in watercolor paintings is a vast project filled with a varied choice of materials and surfaces. This part of the book describes many of the papers and other surfaces available that can be combined with surprising and innovative watercolor techniques. To begin, look at *The Net Checkers*, which uses an acrylic underpainting on Fabriano hand-made rough paper that, according to Arne Lindmark, "takes a wash and holds the beautiful surface for future glazing."

"The picture that looks as if it were done without any effort may have been a perfect battlefield in its making."

—ROBERT HENRI

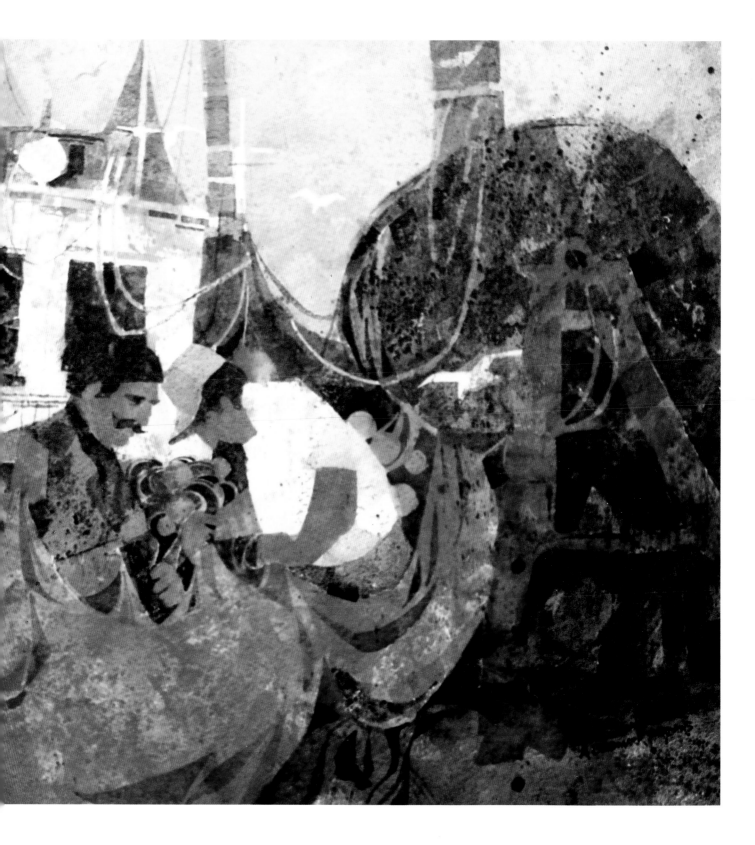

Paper: It's Your Choice

Today there is an ever increasing range of papers to choose from, including the standard well-known papers distinguished by their surface variations: smooth or hot-press, cold-press (moderate texture) and rough, which gives ultimate "tooth" or surface texture. Add to these illustration boards, watercolor paper mounted on boards, new all-media boards, tinted watercolor papers, and the choice of acid-free or pH-neutral. By this time our heads are spinning.

Illustrated on these two pages are sixteen varieties of papers from different manufacturers, in different weights, colors and surface textures. The brushstrokes of green paint clearly show these surface textures, as well as two methods of lifting the color.

It may help you to create a chart similar to this one to test different papers. Phthalocyanine green was used here because it is a highly staining color and one of the most difficult to lift off. A stroke was applied to each paper sample to obtain solid coverage as well as a dry-brush effect. The less successful lift on each test stroke was created by loosening paint with a moist bristle brush and removing it with a tissue. The sharper-edged lift was accomplished by masking the area off and using a moist sponge to loosen and remove paint. The area was then wiped with a tissue.

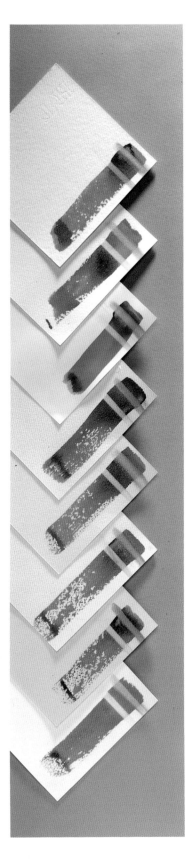

From top to bottom, the papers are:
Waterford 300-lb. rough, Waterford 140-lb.
cold press, Waterford 90-lb. hot press;
Bockingford 140-lb. papers in Oatmeal,
Eggshell, Cream, Grey and White.

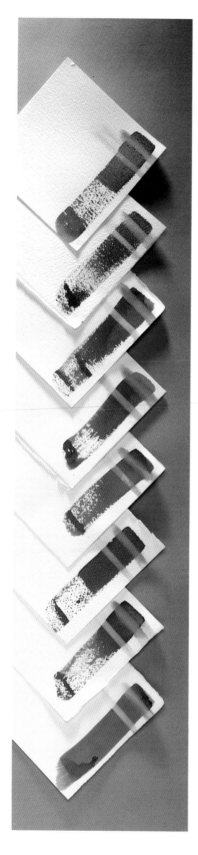

Some of the contributing artists in this book rely on "old faithfuls" and stick to one paper. Others add the newest kinds of paper to their repertoire. The consensus is that more experimentation is happening in the watercolor field. And isn't it about time? The development of new surfaces and paints promotes exciting and stimulating growth. This, in turn, adds to a wide variety of results in the white-paper energy presented by this group of inspired watercolorists.

Of the thirty-five painters featured in this book, four use art or illustration boards, and all use weights ranging from 140-lb. to 300-lb., and even 555-lb. papers. So that you can see the contributing artists' preferences, the first time an artist's work appears in this book, the caption lists the paper preference of that artist. The step-by-step demonstrations describe the procedures and the materials they use.

"John Singer Sargent almost always used white paper for its light-reflecting qualities, but the paper texture varied from smooth to lightly grained."

—HARDIE ABOUT JOHN SINGER SARGENT

From top to bottom, the papers are: Whatman 140-lb. cold press, Whatman 140-lb. rough, Lanaquarelle 140-lb. cold press, Fabriano 140-lb. hot press, Fabriano 140-lb. cold press, Arches 140-lb. rough, Arches 140-lb. cold press and Arches 140-lb. hot press.

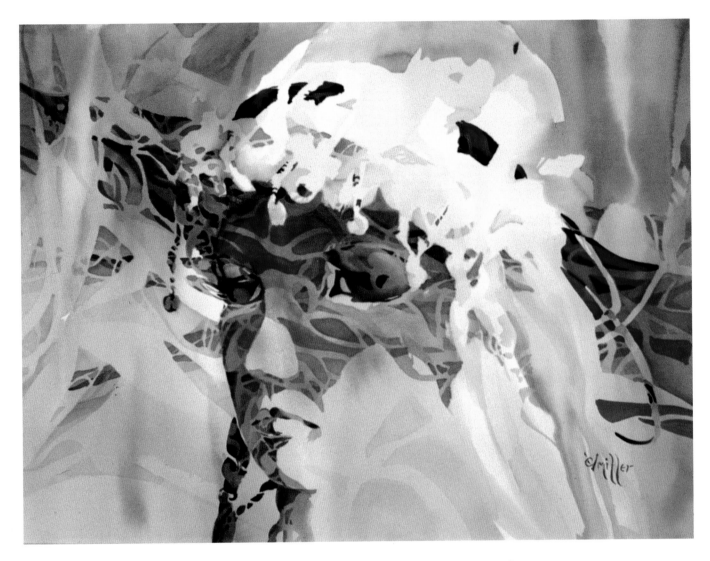

Carl Vosburgh Miller

Gail
18" x 24"
Carl Vosburgh Miller

"I'm a practicing transparent watercolorist. I go to great lengths to save pure white paper because you can never get it back. White paper is the charm of watercolor. Saved whites can be very special in a painting."

Miller says he uses mostly 140-lb. Arches because "it is tough and takes a lot of scrubbing. However, on Winsor & Newton and Indian Village papers, the whites or lights are easier to recover."

For special effects he uses "special techniques that include washing out, masking to recover lights, and often a lot of negative painting."

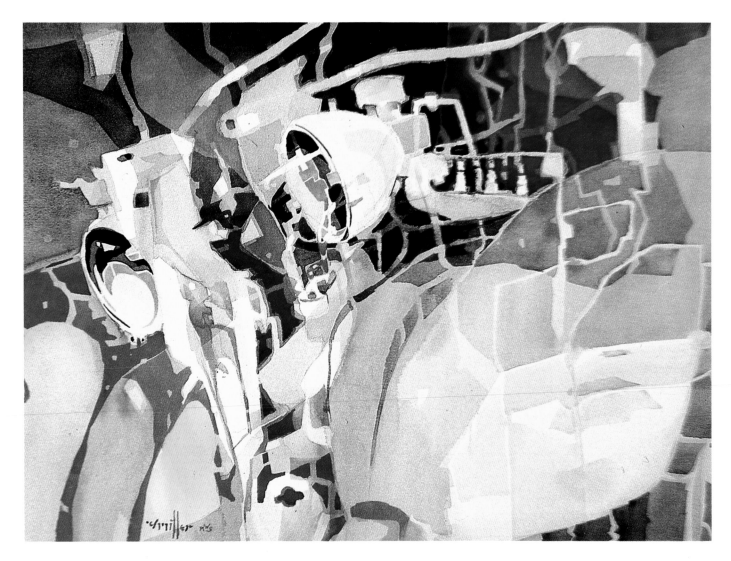

Running Lights

20" x 28"
Carl Vosburgh Miller

Arne Lindmark

Arne Lindmark uses Fabriano handmade rough paper because "it takes a wash and holds it." He also underpaints with acrylics for future glazing. "I use acrylics because they are permanent and will not be disturbed by subsequent washes. I also set up some textures for added interest."

The black-and-white value sketch (far left) is an integral part of my painting procedure—the most important, actually.

This sketch of the white areas is used for the point of interest. I design it as one shape with various elements being part of that shape.

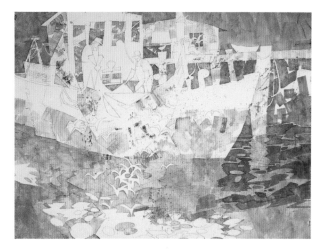
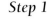

Step 1

With mid and light values of brilliant purple and brilliant blue-purple acrylics, as well as warm sepia watercolor, I start staging the white shape. I use the acrylics because they are permanent and will not be disturbed by subsequent washes. I also set up some textures for added interest.

Step 2

Using burnt umber, permanent blue and permanent magenta, I start a glazing process over my underpainting, stating color while further staging the white area. I seldom mix paints on the palette. By using glazes, I let the eye do this job, which to me is a much fresher approach.

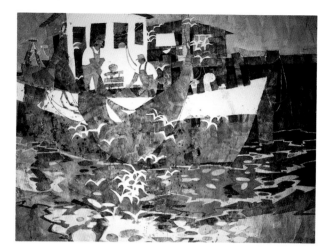

Step 3

At this point, I add the tinting colors: burnt sienna, Winsor red, Antwerp blue, cerulean blue and brown madder. These I glaze over my previous textures and colors. The white shape is now completely staged. Note the play of warms against cools at what will be the point of interest.

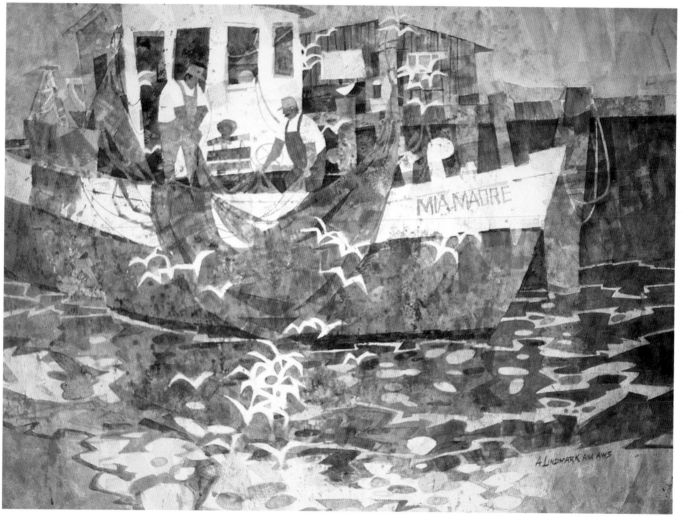

Mia Madre

22" x 30"
Arne Lindmark

Step 4

In this final stage, I put on the darkest dark, using Winsor violet and Thalo blue. Most of the darks are placed against the white shape since it is the point of interest. Nearing the edges, I tint the white shape with burnt sienna and permanent rose.

CHAPTER SIX
Three Ways to Save Whites

Throughout this book, the contributing artists have emphasized the importance of their preparatory sketching methods. These are ways to plan for and hold on to those all-important lights in our paintings. In the aggregate, it comes down to selecting a subject that offers an exciting white or light pattern, or to superimposing such a pattern onto that subject. The planning stage is paramount. Then, during the painting process, we have to hold on to those precious whites and keep our eyes open for other exciting possibilities the painting surface communicates to us. There is no need to enslave ourselves to the planning sketch, but the axiom is: Failing to plan is planning to fail.

Fancy Chicken Coop
15" x 22"
Tony van Hasselt

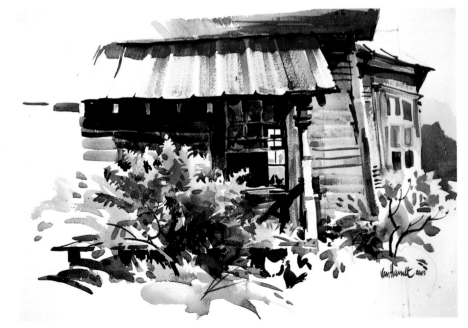

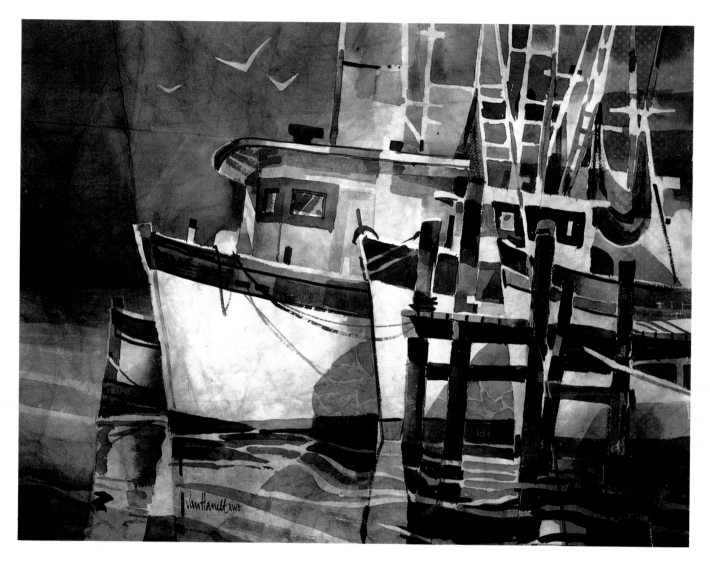

Planning for Whites

Light Refractions was started by creasing the dry paper along focal-point areas, then thoroughly wetting both sides and applying a predominantly blue underpainting while leaving whites at good locations. The limp paper was crumpled up to get the batik effect, then opened out, stretched and stapled to a board. After the paper was completely dry, the subject was painted on top, following the crease lines. The background sky washes were added to push the boats forward, carefully painting around masts and rigging. In contrast to the cool dominance, warm pilings and the boats' trim and reflections were added in a decorative manner.

Light Refractions
18" x 24"
Tony van Hasselt

Frank Webb

Right from the preliminary sketch of *Skidmore Farm*, Frank Webb plans the all-important placement of the whites against other broad value patterns. Although he treats the viewer to a variety of techniques in this step-by-step demonstration, he never loses sight of those important white shapes.

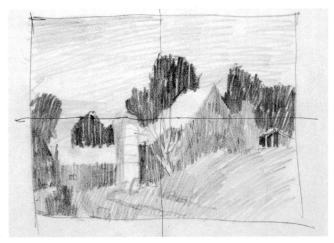

Step 1

I start with a small graphite sketch, using four tonal values to get value masses without relying on contour lines. The darkest darks are placed near the whites. I deliberately leave roofs white, representing reflective metal. The two center lines are added to help transfer the drawing to the larger watercolor paper.

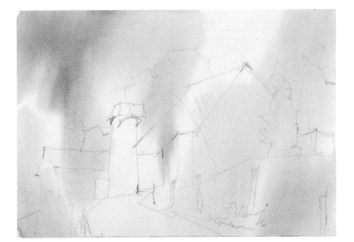

Step 2

After transferring the shapes onto a sheet of 140-lb. cold-press paper, I wet the paper back and front, then place it on a Masonite board. Light washes of blue and green are added to provide a cool, soft-edged base for the warm washes to follow. Any color looks more interesting when it includes a whisper of its complement.

Step 3

While the blue wash is still wet, I add yellow ochre in the sky and alizarin crimson to the right, which results in a more luminous, green effect grading into pink. I avoid having surplus water in the brush as I paint around the all-important whites. Then I add heavier ochres in the foreground.

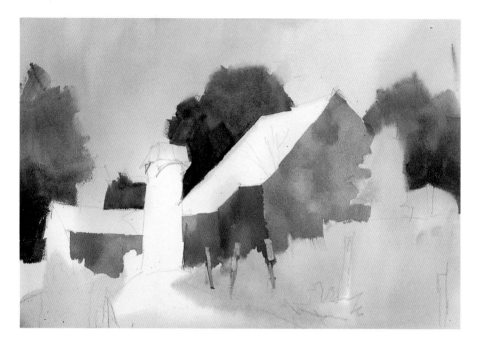

Step 4

Darks are placed behind and around the barn structure while the paper is still wet enough to maintain soft edges. Notice the variety of edge quality in the trees—some rough, some hard, and some soft and blended. Midvalues are applied to the barn sides with variations in color but not in tonal value. A glaze is laid over the foreground, adding bushes and a violet color on the road. While these washes are still wet, I squeegee some negative grass shapes up from the bottom margin.

Skidmore Farm

15" x 22"
Frank Webb

Step 5

The finishing touches include shadows on the silo (notice how I changed light direction from the sketch), a cast shadow on the roof and the sapling in the center, which adds interest to the large white piece. A few calligraphic strokes are added to the smaller roof, the fence posts and the silo hoops. A bare tree introduced on the left fosters a spatial sensation and echoes other linear additions. Finally, small accents of dark are added to the right.

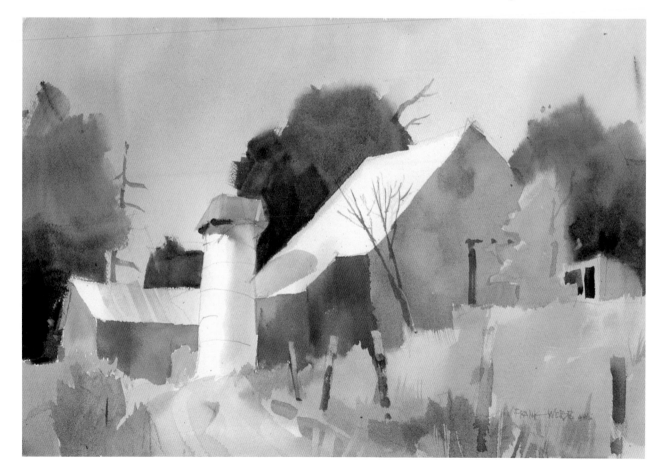

Saving Whites in Abstract Underpaintings

Even during the process of creating an underpainting, it is important to think of saving whites at focal-point locations and repeating them elsewhere for balance. Below are two examples of this type of under-painting—one in cool colors, the other in warm. Compare the white areas saved here with the same areas in the finished paintings on the facing page.

When creating this type of underpainting, be sure to keep the paper wet on both sides to avoid hard edges. Select a temperature dominance and apply appropriate colors to the wet sheet. Keep values in the range of light to midvalue, and save those whites. Use accent colors to help establish the dominance. If colors are applied in equal measure, dominance is lost. Have fun with this and think of balance and repeats at all times. A good underpainting can be used horizontal-ly or vertically. There should be no "right side up."

Cool Underpainting

Warm Underpainting

Step 1

I always do a same-sized pattern sketch for my on-location painting. Then, a few days later back in the studio, I'll do another one, going just by memory. I use good quality smooth drawing paper and, without a prior drawing, paint in the darks *just* in a midvalue gray. That way I can create understandable and balanced shapes and patterns.

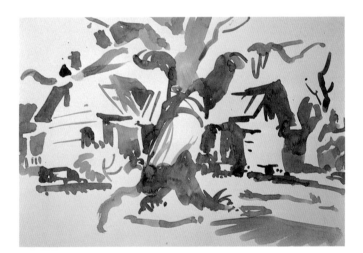

Step 2

I select a dry underpainting and, with the help of the pattern sketch, start placing the shapes on top of it. This is "magic time," when a realistic subject emerges out of the abstract underpainting.

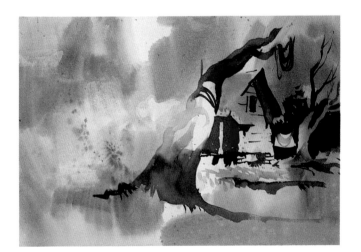

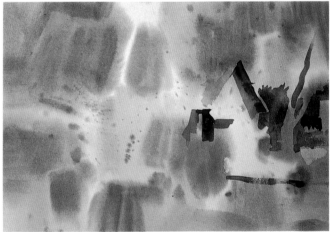

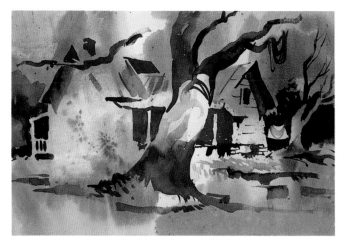

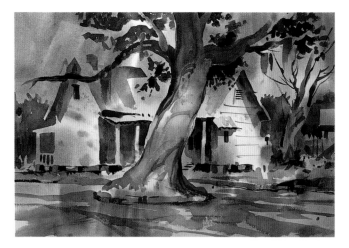

Step 3

I consider all white areas in the pattern sketch as if they are transparent "holes" through which I want to enjoy the beauty of the underpainting. I am very reluctant to glaze over and destroy that beauty. The white areas on the pattern sketch represent the light to midvalue range on the underpainting, and I add the darker values only after paying close attention to what the underpainting suggests to me.

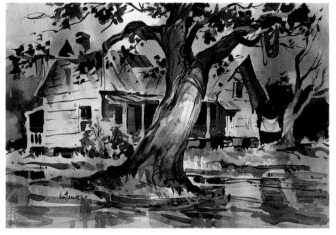

Rainy Day Cottage
15" x 22"
Tony van Hasselt

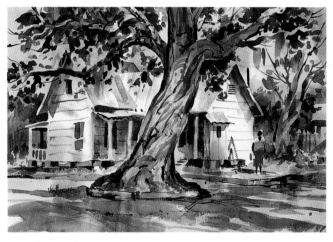

Southern Cottage
15" x 22"
Tony van Hasselt

Step 4

Note the mood difference in these two versions of the same subject. I spend a lot of time looking at how a painting progresses and add final touches as they become clear to me. For instance, the cool underpainting created a rainy-day feeling, which was then developed into street reflections. The warm underpainting, on the other hand, created a sunny-day feeling. This underpainting approach results in paintings that seem to have an inner glow. It creates color combinations I do not normally get when painting on location.

Preserving Whites by Masking

Pat Deadman "White paper is the vital part of a fresh and exciting watercolor. I plan around the white, preserving it for special emphasis, and I depend on the color and design to support and enhance those whites. I have developed an exciting way to preserve the whites by taping cut pieces of waxed paper onto the dry watercolor sheet. I then wet the paper and flood colors on, allowing them to mix to give a midtone. When the paper is dry, I remove the tape and waxed paper and add pure rich color and strong darks."

Step 1

Using 140-lb. Arches cold-press paper, I create a line drawing of vertical and overlapping shapes.

Step 2

Next, I cut similar shapes out of waxed paper and tape them down, overlapping them, but not copying the line drawing.

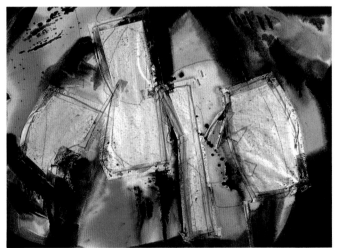

Step 3

The paper is moistened with clean water, and color is flooded on and allowed to mix to a midtone. While the paper is drying, textured areas are added for a soft-edged effect; once the paper is dry, some hard-edged spatters add a different effect.

"The artist's problem is to create

art, whether the forms be objective

or nonobjective."

—MILFORD ZORNES

Step 4

When the paper is completely dry, the waxed paper and tape are removed, exposing generous whites in a muted midtone.

Pieces of Light I

22" x 30"
Pat Deadman

Step 5

Bright color accents are painted into the whites. Dark values accent the whites and create new, repeated shapes in the midtones.

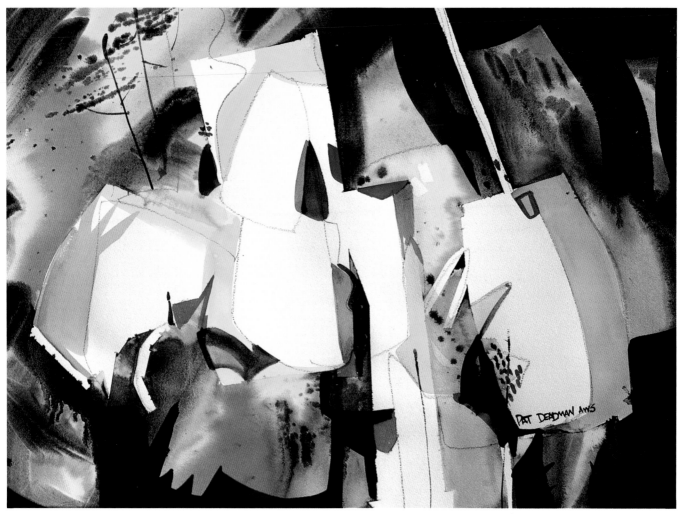

Step 1

Once the drawing and design are laid out in definite lines on my paper, I cover the area with heavy 2" masking tape, lightly tapped or smoothed down to make sure the pencil lines are visible through the tape. Next, I use a craft knife with a somewhat dull blade to cut the tape along the pencil lines. I am careful not to score the 300-lb. paper. Then I carefully pull up the unwanted tape at a low angle and remove it.

Step 2

I once again check the adhesion seal of the tape on the paper. (Always use fresh masking tape and leave it on the paper surface for only a very short time.) The remaining shape, in this case the plant, is ready for the painting process.

Taping works well on an unpainted surface but is unsuccessful where an opaque paint has dried. By experimenting with different types of tape and differences in stickiness and other properties, you can avoid fuzzy edges or an uneven rendering.

Step 3

For large areas, I mix my colors in clear plastic cups and apply them using a wide hake brush.

Warren Taylor

"The white area left in a watercolor, be it large and obvious or the size of a stamp, is the trump card—the single card left in the hand at the end of the game."

Taylor seldom uses liquid masking fluid. Instead, he covers the drawing with heavy masking tape and cuts it into the shape of the white to be protected.

In a recent series of Taylor's paintings, an agave or century plant forms a dominant, unifying theme in a complex assemblage of images. This large plant form is thus the first priority, and its fresh and spontaneous rendering sets the tone and spirit for this demonstration on using masking tape to save whites.

Step 4

When the paint is dry, the remaining tape is slowly and carefully removed.

When drawing a detailed area such as the lower left-hand corner of this painting, I use visual notes to remind myself where highlights, shadows and dark areas are located—a dot for highlights, an x for darks, dotted and dashed lines for structural and cast shadows. After painting, the marks are erased.

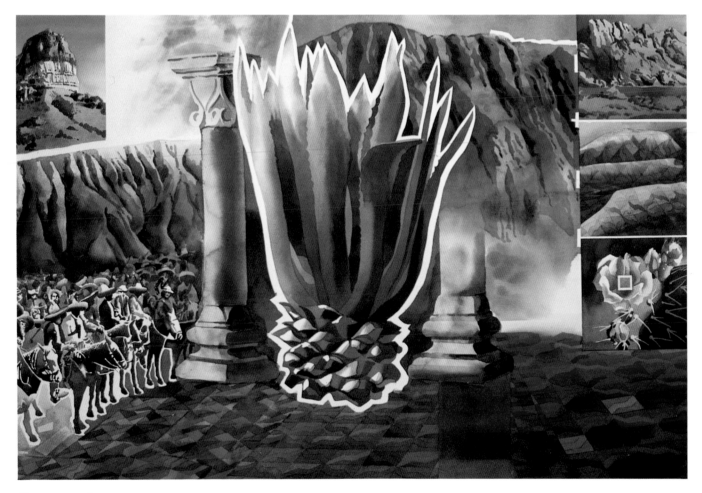

Coyanosa Agave

34½" x 55"
Warren Taylor

George Kountoupis

"*Gingerbread House* depicts a typical scene in Eureka Springs, Arkansas. I've painted in this area for years. Lately, it has become a very popular tourist spot.

"This unique house offers many possibilities to save some white paper. There is nothing so attractive as pure white paper untouched by pigment."

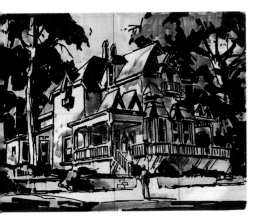

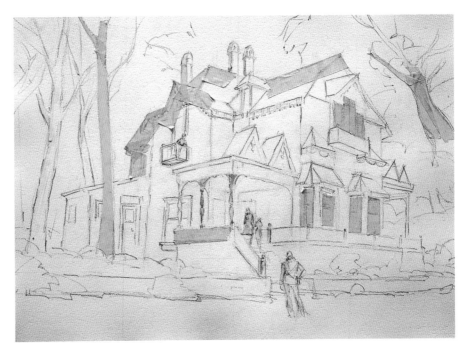

Step 1

I start with a carefully worked out value and composition study. I may do several of these before deciding on one. I superimpose a simple grid line to assist with enlarging the drawing.

Step 2

I enlarge the drawing on a full sheet of 300-lb. cold-press watercolor paper. I use masking fluid or tape on areas I wish to leave white.

Step 3

Using a 3-inch brush, I wet down the entire area around the house. At top right, I immediately charge in alizarin crimson and cadmium orange, followed by a green mixture made from Payne's gray, raw sienna plus a little ultramarine blue. The values run from light to middle light. At top left, I put warm and cool greens of the same values. Next, I balance some of those greens in the foreground on the lawn and bushes. The street gets a wash of manganese blue and permanent rose, with some areas left white. When these areas are dry, I remove the masking tape from the roof and other areas but keep some of the windows and trees masked off.

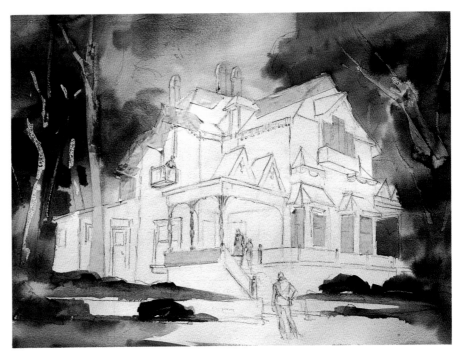

Step 4

I lay in the shadows of the house using cobalt blue and permanent rose, adding orange at the base for reflected light. While these areas are drying, I add darker values in the tree foliage at the top of the paper using the same colors as earlier, with some cadmium red for accents. When everything is thoroughly dry, I remove all the remaining masking fluid and tape.

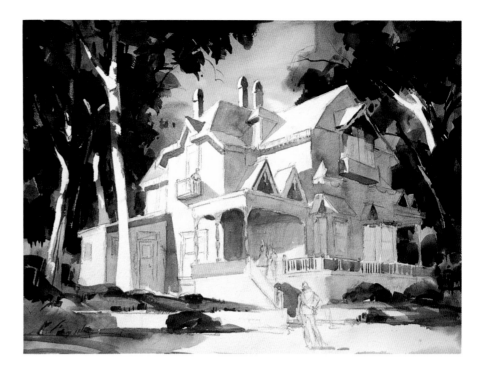

Step 5

I now add the final details such as windows, doors, cast shadows of trees and figures. I adjust any values that are not quite right. Under the porch, I show a warm, reflected light bouncing up from the floor onto the walls. To complete the painting, I use a rigger brush for a few twigs in the trees and bushes.

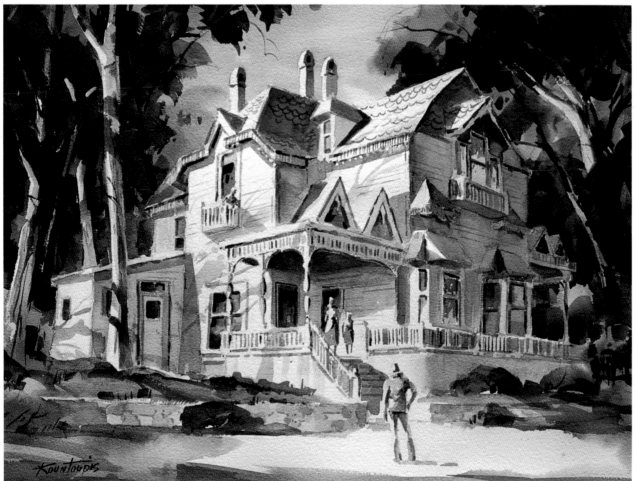

Gingerbread House

22" x 30"
George Kountoupis

CHAPTER SEVEN
Six Ways to Let Whites Show Through

Keep It Transparent

The difference between an opaque medium and transparent watercolor is that in watercolor, the light is allowed to travel *through* the layers of paint and bounce off the white paper surface. In an opaque medium, the light hits the *surface* of the top layer of paint and bounces that color back to the viewer. Not every section in a watercolor needs to be transparent, but those that are should be painted as directly as possible, with minimal layers of paint. The more layers or glazes, the more transparency suffers.

Lighthouse Museum
22" x 30"
Judi Wagner

Robert Sakson

"I don't use any special effects or masking out. I just paint a traditional transparent watercolor. I usually plan for all the whites and use the white paper as the brightest bright. All values contribute to that white space."

Waiting for Allen

29" x 36"
Robert Sakson
Sakson uses Arches and Saunders papers.

"It is my philosophy that a work of art is nothing more than the sharing of a feeling or experience. This must be done on a very personal level to be fine art."
—WILLIAM F. REESE

Dale Laitinen

"The key to transparency is what you put next to it, darks or more opaque passages, also intensity versus subtle transparency. I begin with strong abstract design and work toward specifics as the painting progresses. The first step is with pencil and paper, spending time free-associating in order to come up with design and pattern. The heart of the process is the layering and drying. I lay in wet washes, mingling color and changing values. To get crisp edges, I let the wash dry and lay new washes on top, resulting in crisp versus subtle transition that is important to luminosity.

"I leave whites to create flickers of light, especially in tree branches. For textured effects on logs, branches or rocks, I apply dry-brush techniques that leave specks of white, and outline them for emphasis. Painting spaces between objects is important to me. By painting around whites, not using masking agents, I can retain the spontaneity of the negative and positive shapes.

"When going beyond transparent watercolor, I use opaques, gesso, gouache and Prismacolor, weaving them into the painting and juxtaposing them against the transparencies and whites of the paper. I like Arches paper because the surface enhances the granulation in washes. It absorbs nicely and holds the color for subsequent layers. I sometimes mix my colors with a 50/50 solution of Elmer's white glue and water to make a thin glaze. This glaze dries transparent and makes a more water-resistant layer, which increases transparency and luminosity, and prevents the underneath washes from lifting."

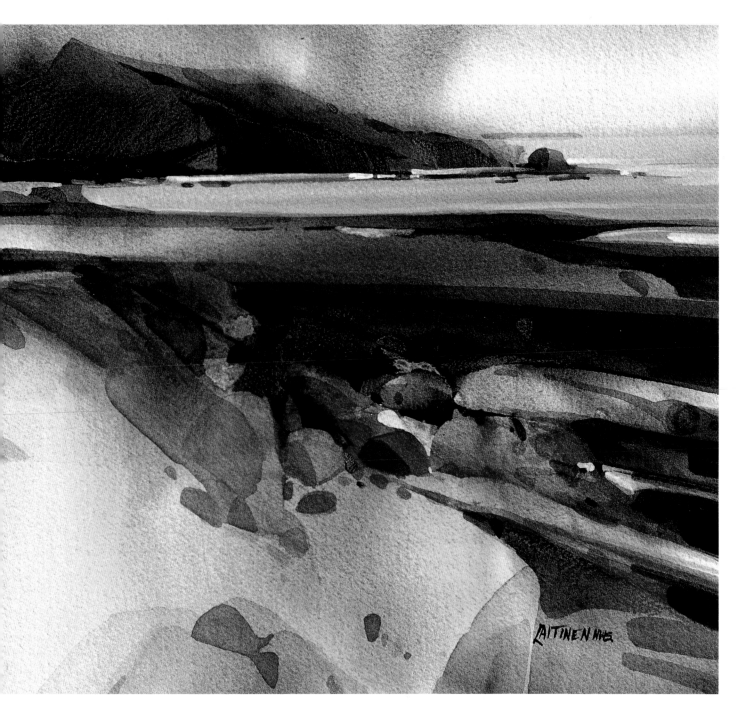

Low Tide

14" x 22"
Dale Laitinen

Enhance Whites Through Gradation

Gradation is *change*. Values can change from light to dark, color from bright to neutral, or hue from warm to cool. Shapes can gradually become larger or smaller, and textural complexity can gradate as well. Gradation brings excitement to a painting. Without it, planes can become flat and uninteresting.

Using an underpainting, such as pictured here and on pages 106-107, guarantees gradation and change in a painting. The transparency of the abstract colors shows through the final watercolor, providing changes and "happenings" unthought of in a conventional approach to the same subject matter.

Once the painting is superimposed onto an underpainting, as in *Kingsley Impressions*, the light-value modulations create "whites" that are full of additional character. The building still reads as a white building in the sun as well as in the shadow sections.

A warm underpainting similar to the one used for *Kingsley Impressions*.

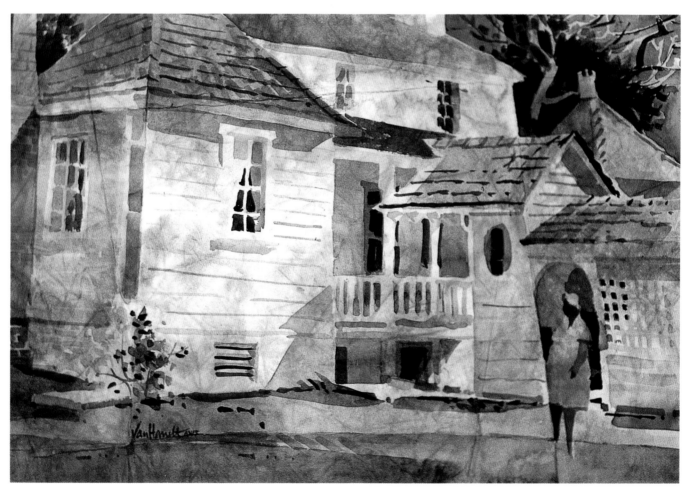

Kingsley Impressions

15" x 22"
Tony van Hasselt

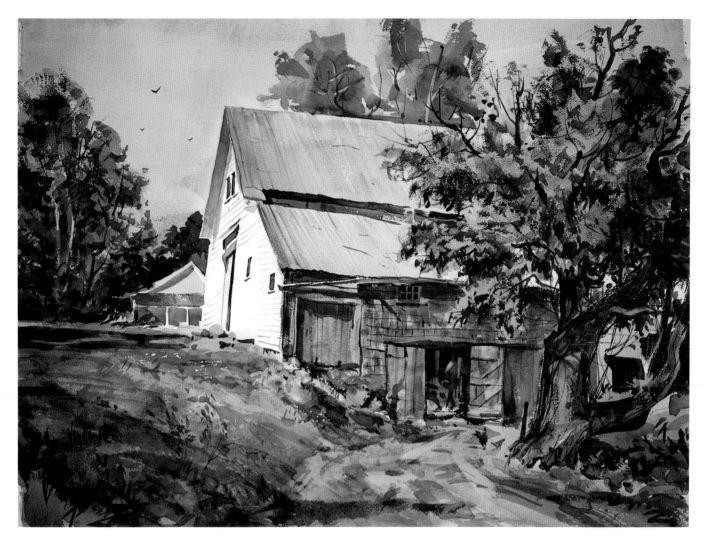

In *Mr. Stewart's Place*, the artist employs an effective use of foreground gradation leading the eye up to the brilliant white facade of the barn. Painted on 140-lb. Arches with the whites left as untouched paper, the scene has as its theme a strong New England piece of architecture.

Mr. Stewart's Place

22" x 30"
Tony van Hasselt

Vary Edge Quality

In watercolor, we do not have the tactile textures enjoyed in oil. To simulate this effect, however, we can use a variety of edges from soft to hard. In landscape painting, the area to be painted often gives us clues as to how to treat an edge. For instance, clouds would generally be soft-edged, buildings in comparison are hard-edged.

In *Green Apples*, the artist gives us some wonderful edge variations. The soft edges of the uncut apples express their roundness and the hard-edge of the cut apple is used to express its knife-sharp edge. It's important to keep the sharpest edge at or near the center of interest since this creates an "in-focus" look.

"The artist conveys what he knows about feelings, which is knowledge."

—SUZANNE K. LANGER

Green Apples

12" x 15"
Aldryth Ockenga

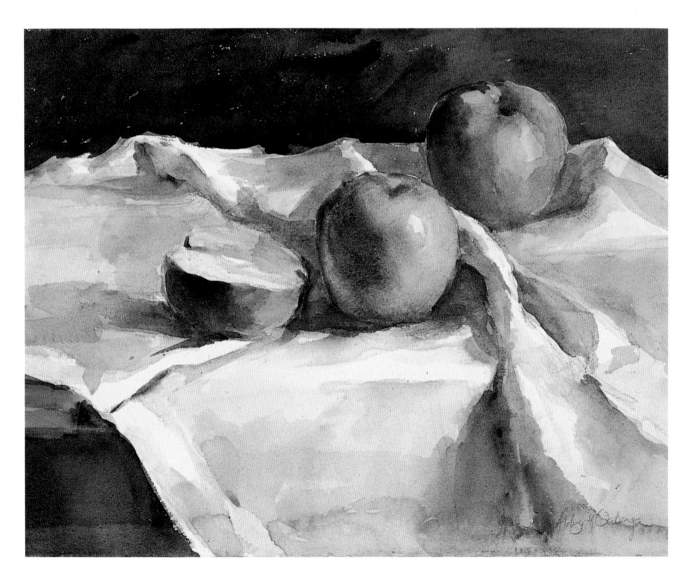

Texturize Whites With a Dry Brush

Dry-brush strokes are joyous marks that, when placed against the whites of the paper, read easily while letting the white show through. One method is to drag the brush parallel with the paper so you hear the ferrule scraping on the surface. Another method is to dry the brush with a cloth, and using fresh pigment and very little water, spread the brush hairs to mark the paper. At other spots, you may use a fully charged brush and push the brush against the grain of the paper to create interesting edges.

By keeping the center of interest hard-edged and accented with dry-brush strokes in *Monhegan Rock Slide*, the artist has conveyed clearly the story of the painting. The gradated washes on the foreground rockslide are shaped as a pointing device to the subject. The light-struck rock faces, represented by white paper, separate and push back the island shape beyond.

Monhegan Rock Slide

22" x 30"
Judi Wagner

Leave White Space Around Shapes

Colorado Farm House and *Eaton Corner* resulted from a class exercise on the importance of complementary colors. By separating each shape with a white border, the artist had time to contemplate what color to place next to the shape previously painted instead of just copying nature. The result is a simplicity of design that also points up the importance of good shape-making.

If the artist were to separate these colors with a black line, the effect would be similar to a leaded-glass window.

Colorado Farm House

15" x 22"
Tony van Hasselt

Eaton Corner

15" x 22"
Tony van Hasselt

Add Sparkle With Spatter, Sprays and Runs

The light mid-tone of the ground plane in *Adobe Abode*, while still moist, was modulated by flicking in paint with a bristle fan brush and using fingers to flick in clear water. A pleasing textural effect is the result with a variety of marks used to suggest foreground activities. By repeating this procedure once the area is dry, the resulting spatters are hard-edged. Some artists knock a loaded brush against another brush to flick paint spatters into areas to be modulated.

Spraying a mist of water using a spray bottle can soften an area or push texture in a plain wash. Using the spray technique can be the touch that completes an idea.

Runs with or without control have valid uses. Mary DeLoyht-Arendt comments: "I paint a pretty direct watercolor with spatter and drips to help loosen up my tendency to be too tight as the result of my commercial art background."

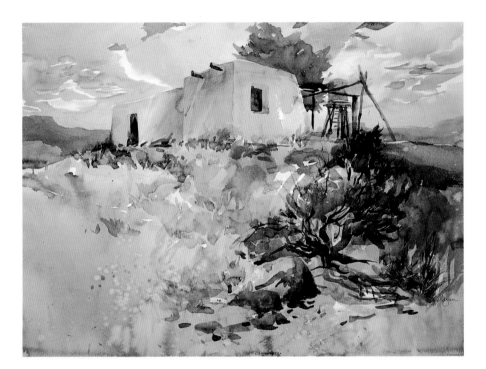

Adobe Abode

22" x 30"
Judi Wagner

Marina

22" x 30"
Carl Vosburgh Miller

White House Roses

30" x 22"
Mary DeLoyht-Arendt
Collection of Dr. Kathryn Kendall

Five Ways to Get the White Back

The creative options for working with a white paper surface are boundless, as are the big questions that usually come up: "What is needed in this composition? What tools? What can I do to return the paper to white?"

Here you will see how several artists use five very simple techniques to recover white paper: scrubbing, salt, scraping, squeegeeing and razor blades.

Holyoke Brick

17" x 21"
Donald Stoltenberg

Glory of Sail

21½" x 29"
Donald Stoltenberg

Donald Stoltenberg "I always leave some white paper in its purest state. I use Arches paper because I like the way it takes paint and is scrubbable when I apply masks, stencils and sponges to get the white paper surface back. I sometimes use Chinese white to heighten or contrast whites."

Scrubbing, Scraping, Salt and Other Ideas

Step 1

After observing this painting awhile, the artist decided that it needed a center of interest. Some areas in the upper-left portion were moistened with water. Scrubbing with a small, short-haired bristle brush, the artist loosened the paint and picked it up with tissues. The scrubbed-out areas are obviously larger than they need to be.

Step 2

After removing most of the paint, the artist filled in the background around the birds to reclaim the proper silhouettes. Then the details of the bird shapes were completed using a light hand. Since it was impossible to fully regain the white of the paper, some Chinese white was added where needed.

All Clear for Landing

15" x 22"
Tony van Hasselt

Fernandina Shrimper

15" x 22"
Tony van Hasselt
Collection of Harry Madson
While the basic blue wash was still moist,
the bird shapes, masts, rigging and some
wave reflections were scraped or actually
squeegeed out with a dull, round-edged
pocket knife.

Timing is important with this tech-
nique. If the surface is too wet, the scrape
will damage the paper, and a dark mark will
result. If the surface is too dry, paint can no
longer be squeegeed out.

"Life is very interesting, if you make enough mistakes."

—JOHN PIKE

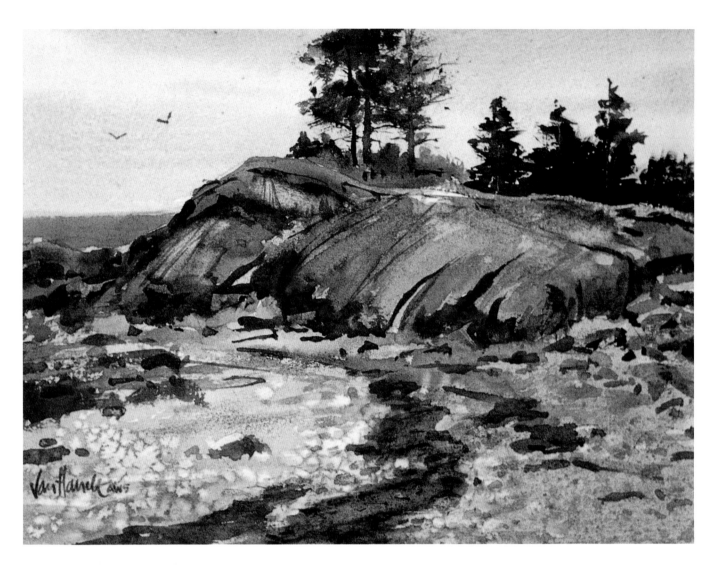

Corrine's Beach

9" x 12"

Tony van Hasselt

The foreground beach area was stated with a warm wash and, when it was almost dry, salt was sprinkled into it. After it was completely dry, the salt was shaken off, and this beach texturing was the result.

Some experimenting is needed with this technique. If the salt is sprinkled into a very wet wash or if a very pale wash color is used, this effect will not be attained.

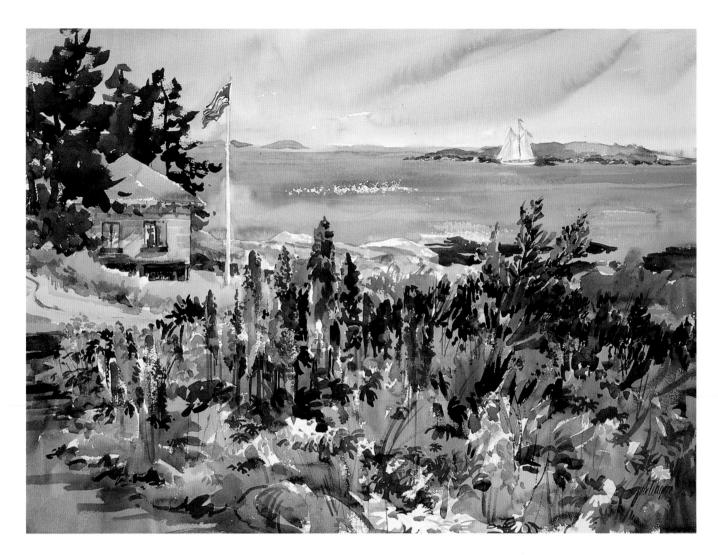

Seaside Garden

22" x 30"
Judi Wagner
Whites appear in various forms in this view off Ocean Point, Maine. First, sparkling whites of reflected sunshine were captured in the dry-brush stroke on the water. Then whites were painted around in the foreground flower garden. A gently scraped, single-edged razor blade cleaned up the flagpole white and the silhouetted sails.

CONCLUSION

The serendipitous joy of writing and compiling this book has been the opportunity to take a pause from our own painting, teaching and judging endeavors in order to *really* look at the important role of white paper in watercolor. After receiving an enthusiastic response from so many contributing artists, our own love of white paper was confirmed. We were not alone.

Together with these contributors, we hope we have been able to present an inspiring new look at that untouched paper surface. Personally, we have become even more convinced about acting with restraint when covering up those precious whites. They *are* precious. White is light and *light is life itself.*

We thank all the contributing artists for their excellent submissions and warm interest in our project. This sharing of feelings, ideas, awareness and growth charged us with even more enthusiasm to work on this project. It wasn't work, however. It was *joy!*

"I believe talent is God-given, a gift,

not to be wasted. Use your gift.

Perfect it!"

—WILLIAM F. REESE

Stepping Out on a Windy Day

22" x 30"
Judi Wagner

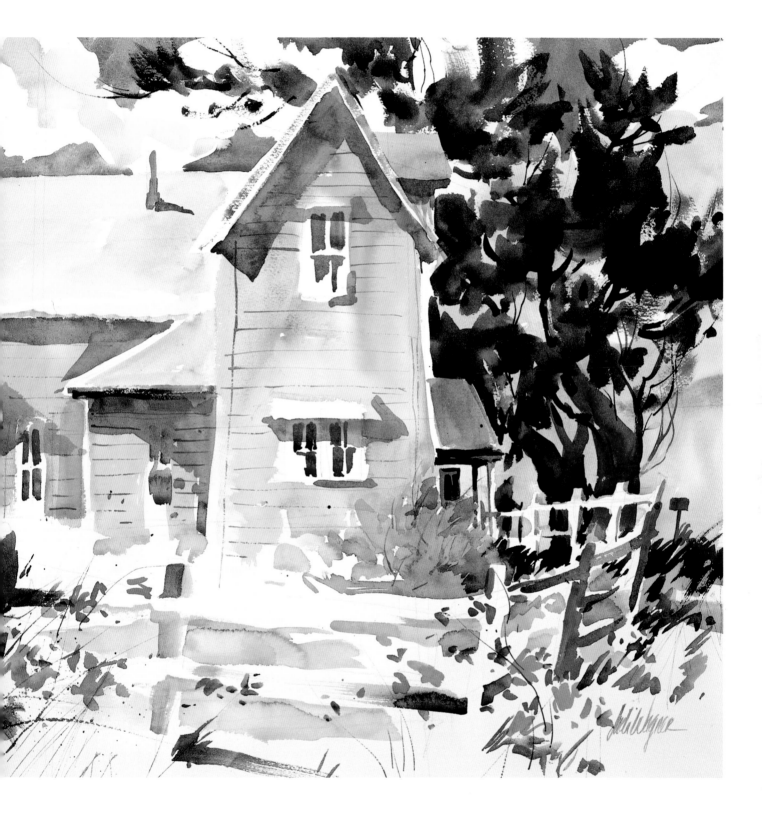

INDEX